A MATTER OF
LIFE AND DEATH

GARLAND REFERENCE LIBRARY
OF THE HUMANITIES
(VOL. 90)

A MATTER OF
LIFE AND DEATH

*Vital Biographical Facts
about Selected American Artists*

Arnold T. Schwab

in cooperation with
the Art Libraries Society
of North America

GARLAND PUBLISHING, INC. • NEW YORK & LONDON
1977

Library of Congress Cataloging in Publication Data

Schwab, Arnold T
 A matter of life and death.

 (Garland reference library of the humanities ;
v. 90)
 Includes bibliographical references.
 1. Artists--United States--Biography. I. Arlis/
North America. II. Title.
N6536.S35 709'.2'2 [B] 76-52694
ISBN 0-8240-9883-8

To my father
and the memory of my mother

CONTENTS

ACKNOWLEDGMENTS

During the years that I have been working on this project, I have had a good deal of help from many institutions and individuals. In acknowledging it now, I hope I have not overlooked anyone and that any inadvertent omission will be forgiven. To list every organization or person who replied to my countless inquiries would, however, take up too much space. Regretfully, therefore, I must confine this list to those who actually provided useful information, although I am certainly grateful to the others, too.

My greatest debt is to the library of California State University at Long Beach (where I teach), which subsidized most of the cost of obtaining birth and death records. In addition, its staff, especially the fine arts and social science reference librarians, answered innumerable questions with unvarying patience and courtesy. Indispensable, too, was the aid of the stenographic bureau of the University, which typed part of the manuscript for photographic reproduction.

I also received much assistance from the Long Beach Public Library, particularly from its telephone-directory service. Seldom, during the last few years, did a day go by without my calling in for at least one address or checking its excellent collection of phone books myself.

I would like to thank the following libraries and other institutions where I worked from time to time: Los Angeles Public; Boston Public; Library of Congress; New York Public; University of California at Los Angeles Art Library; Archives of American Art, Washington, D.C.; Copyright Office, Washington, D.C.; Federal Records Archives Center, Laguna Niguel, Calif.; and the MacDowell Colony, Peterborough, N.H.

The main public libraries at the following locations answered queries by mail: Bronxville, N.Y.; Buffalo; Charleston, S.C.; Chicago; Cincinnati; Columbus, Ohio; Denver; Detroit;

Englewood, N.J.; Evanston, Ill.; Glenside, N.J.; Hamilton, Canada; Ipswich, Mass.; Jackson, Mich.; Lake Forest, Ill.; Manchester, N.H.; Melrose, Mass.; Melville, N.Y.; Miami, Fla.; Milford, Va.; Milwaukee; Morristown, N.J.; New Rochelle, N.Y.; Newton, Mass.; Newtown, Conn.; Oklahoma City; Orlando, Fla.; Oyster Bay, N.Y.; Pasadena, Calif.; Philadelphia; Portsmouth, N.H.; Poughkeepsie, N.Y.; Rahway, N.J.; Roswell, N.M.; Russell, Kans.; San Francisco; Sante Fe, N.M.; Short Hills, N.J.; Sloatsburg, N.Y.; Stroudsburg, Pa.; Swarthmore, Pa.; Syracuse, N.Y.; Titusville, Pa.; Westport, Conn.; White Plains, N.Y.; and Wilkes-Barre, Pa.

The library or alumni office of the following educational institutions supplied helpful data: Albion College, Albion, Mich.; Amherst College; Art Center, Maitland, Fla.; Art Institute of Chicago; Art Students League, New York; Carnegie-Mellon University; Charles University, Prague; Columbia University; Convent of the Sacred Heart, New York; Cooper Union; Cornell University; Dana Hall School, Wellesley, Mass.; Dayton Art Institute; Drexel University, Philadelphia; East Stroudsburg (Pa.) State College; Germantown Academy, Fort Washington, Pa.; Millersville (Pa.) State College; New York University; Pennsylvania Academy of the Fine Arts; Pratt Institute; Princeton University; Radcliffe College; Smith College; Teachers College, Columbia University; University of California at Berkeley; University of Chicago; University of Miami; Vassar College; and Yale University.

Obliging, too, were the Allis Art Library, Milwaukee; California State Library at Sacramento; Central Library, Oxford, England; Danes Worldwide Archives, Aalborg, Denmark; Essex Institute, Salem, Mass.; Frick Art Reference Library; Newberry Library; New Jersey State Library, Trenton; and the Royal Danish Academy, Copenhagen.

I would like to express my appreciation to the following organizations:

Galleries: Gibbes, Charleston, S.C.; Graham, New York; Milch, New York; Robert Schoelkopf, New York; Stendhal, Los Angeles; and Robert Vose, Boston.

Museums: Lyman Allyn, New London, Conn.; Boston Museum of Fine Arts; Chrysler, Norfolk, Va.; Los Angeles County; Metropolitan Museum of Art; Museum of Modern Art; National Gallery of Canada, Ottawa; National Gallery of Prague; New Mexico, Santa Fe; Ojai Valley, Ojai, Calif.; Phillips Collection, Washington, D.C.; Portland, Oreg.; St. Louis, Mo.; University of Connecticut; Virginia Museum of Fine Arts, Richmond, Va.; and the Whitney Museum of American Art.

Clubs and Societies: American Contract Bridge League; Arts Club, Washington, D.C.; Beverly Hills (Calif.) Art League; Czechoslovakian Society of Arts and Sciences; Lutheran Board of Publications, Philadelphia; National Academy of Design; National Institute of Arts and Letters; National Society of Daughters of the American Revolution; Philadelphia Sketch Club; Salmagundi Club, New York; and Woodstock (N.Y.) Art Association.

State Historical Societies: Colorado, Idaho, New York, Pennsylvania, South Carolina, and Virginia.

Local Historical Societies: Cape Ann, Gloucester, Mass.; Chester County, West Chester, Pa.; Goshen, N.Y.; Highland County, Hillsboro, Ohio; Long Island, Brooklyn; Marshall County, Holly Springs, Miss.; Old Lyme, Conn.; Onondaga, Syracuse, N.Y.; Rahway, N.J.; Rockland County, Orangeburg, N.Y.; and Santa Barbara, Calif.

Hospitals: Fordham, New York; Johns Hopkins, Baltimore; Lawrence and Memorial, New London, Conn.; Milwaukee Psychiatric, Wauwatosa, Wis.; Mount Sinai, New York; Presbyterian, New York; and Valhalla, N.Y.

Mortuaries: Armstrong, Los Angeles; Brewster, Manchester Center, Vt.; Frank E. Campbell, New York; Walter B. Cooke, New York; Kirk and Nice, Philadelphia; and Ralph M. Morehead, New York.

Cemeteries: Beechwood, New Rochelle, N.Y.; Ferncliffe Crematory, Hartsdale, N.Y.; Fernwood, Fernwood, Delaware County, Pa.; Graceland, Chicago; Ivy Hill, Philadelphia; Lake View, Cleveland; Mountain Grove, Bridgeport, Conn.; Mount Sharon, Springfield, Pa.; National, Philadelphia; Oakland,

Yonkers, N.Y.; Oakwood, West Chester, Pa.; St. Raymond's New, The Bronx, N.Y.; Sleepy Hollow, North Tarrytown, N.Y.; and White Plains Rural, White Plains, N.Y.

Newspapers: Amsterdam (N.Y.) *Evening Recorder*; Baltimore *Sun*; Holly Springs (Miss.) *South Reporter*; Mexico City *Excelsior*; Milwaukee *Journal*; New York *Times*; Norfolk (Va.) *Virginian-Pilot*; Ojai (Calif.) *Ojai Valley News*; Providence (R.I.) *Journal and Evening Bulletin*; Rahway (N.J.) *News-Record and the Clark Patriot*; Riverside (Calif.) *Daily Press*; Roswell (N.M.) *Daily Record*; San Francisco *Chronicle* and *Examiner*; and South Boston (Va.) *News & Record.*

Town Clerks (registrars of vital statistics) of the following: Arkville, N.Y.; Babylon, N.Y.; Barrington, R.I.; Hollis, N.Y.; Locust Point, N.J.; Monroe, Wis.; Monterey, Mass.; Morrisville, Vt.; Mount Pleasant, N.Y.; Peacham, Vt.; Red Hook, N.Y.; Saugerties, N.Y.; Scarsdale, N.Y.; Selma, Ala.; Swarthmore, Pa.; Taunton, Mass.; Truro, Mass.; Waterford, Conn.; Waterville, N.Y.; Westmoreland, N.H.; Wilbraham, Mass.; Woodbridge, N.J.; Woodstown, N.J.; and Yonkers, N.Y.

City or County Clerks (registrars of vital statistics) of the following: Baltimore; Berrien, Ohio; Bethesda, Md.; Bloomington, Ill.; Boston; Charleston, S.C.; Decatur, Ill.; Gloucester, Mass.; Miami, Fla.; New Rochelle, N.Y.; New York; Oshkosh, Wis.; Philadelphia; San Francisco; and Washington, D.C.

State Vital-Statistics Bureaus: Alabama, California, Mississippi, New Jersey, New York, Pennsylvania, Vermont, and Virginia.

U.S. Government Agencies: American Consulate, Florence; Department of State; Embassy, Cairo; Embassy, Paris; Embassy, Rome; National Archival Services, Denver; National Archives, Diplomatic Branch, Washington, D.C.; and National Personnel Records Center, St. Louis, Mo.

Foreign Government Agencies: Canada—Canadian Armed Forces Record Center, Ottawa; Canadian Consulate General, Los Angeles; Canadian Embassy, Rabat-Agdal, Morocco; Registrar-General, Toronto; Czechoslovakia—Czechoslovakian Embassy, Washington, D.C.; Denmark—Danish Embassy, Washington, D.C.; Danish Information Office, New York; France—Town

Hall, Cassis, France; Great Britain—British Consulate General, Casablanca; General Register Office, London; Switzerland— Consulate General of Switzerland, Los Angeles; and West Germany—Registrar's Office, Munich.

I am indebted to the following persons for information or special services. Those whose names are asterisked supplied or confirmed one or more facts: *Mrs. Virginia Payne Ahrens; Mrs. Eugene T. Aldridge; Mrs. George M. Allen; Guy Amen; George Arms; Edd Ashe; Mrs. Antonio Barone; Martin Battersby; *Helen M. Beatty; *Bernard Beck; William C. Bendig; *Mrs. Meyer Berger; Edwin E. Bewley, Jr.; *Mrs. Murray Bewley; Michael Biddle; *Mrs. Gloriana Horter Biegman; Robert B. Blauveldt; *Mrs. Suzanne Boss; *Mrs. Harold Bowditch; Mrs. Oscar Bumgardner; *Howard R. Butler, Jr.; *Dr. Mary S. Calderone; David Carlson; *Robert E. Carlson; *Milton O. Cederquist; Mrs. Katharine S. Chamberlin; *Samuel L. Chaney; David L. Conger; *Maybelle Conger; *Kenneth H. Cook; *Mrs. Percy Coombs; Stuart C. Culin; Stuart R. Culin; *Mrs. Kate H. Cullum; *Alvina Deines; *Mrs. Elena Covarrubias de Rico; *Edith DeShaze; *Mrs. Marius de Zayas; Mr. and Mrs. John E. Dodge; Frances B. Drake; *James M. Eaves; Rudolph Ernst; *Philip Evergood; *Andreas Feininger; Dr. Armin T. Fellows; Mrs. Harold Fellows; *Mrs. Mildred Fellows; *Lewis Ferbraché; Harriet Fitzgerald; *Richard Morley Fletcher; *Robert Morley Fletcher; *Eleanor Funk.

Also, *Mrs. Lee Gatch; *Ira Glackens; B. Paul Gladston; Mrs. Aaron Goldman; *Prof. Marcus S. Goldman; Mrs. John W. Graham; Mrs. Joseph Graves; *Stephen Guglielmi; *Louis Lee Haggin; Dr. Selden Hamilton; *Mrs. Grace Hartley; Patricia Havlice; *Mrs. Morris Henry Hobbs; *John Horter; *Willard Hubbell; *Dr. David J. Impastato; *Mrs. Margery M. Janes; *Eberhard von Jarachowski; Frank E. Karelsen; *George Karfiol; *Mrs. William Sergeant Kendall; *Mr. and Mrs. A. Atwater Kent, Jr.; G. E. Kerlenberger; *Mr. and Mrs. William F. Kirsch; *Louis Kobbé; *Louis A. Koffman; *G. Robert Koopman; Patrick LeJeune; Jeffrey K. Levey; *Mrs. Marjorie Lewis; *Mrs. Charles Dana Loomis; Dr. Louise Lubbe; Anne

Lutz; *George M. MacLean; *Anne M. Manigault; Mrs. Howard
Manning; *Mrs. Herbert Matter; *Mrs. Leonore O. Miller; *Jay
Monoghan; *Isabel T. Morrison; *Mrs. J. B. Mowbray-Clarke;
*Mrs. Rosa C. Nessler; A. H. Nordhausen; Stanley Olson; *Larry
Parker; Gryffyd Partridge; *Edith Patterson; *Mary Perrine;
*David S. Perry; Mrs. Robert E. Perry; *Mrs. Walter M. Perry;
*Mrs. Harwood B. B. Picard; *Mrs. Juanita Piccoli; Yvette
Pinsker; Ronald Pisano; *Mrs. Charles M. Plunket; Mrs. Edgar
W. Postle; *Helen Proctor; *Mrs. Walter Quirt.

Also, Martin F. Rheinhart, Jr.; Gerald Rice; *Mrs. William A.
Rice; Harriet C. Robbins; *George W. Rosner; Marjorie
Ryerson; *Frank Sachs; *Sylvia Saunders; *Mrs. H. C. Sevills;
Hyde Solomon; *Joseph Solomon; *Mrs. Alvin J. Stark; D. H.
Stefanson; *Mrs. Robert C. Steinmetz; Mrs. B. Albert Stern;
Mrs. Eric C. Stern; *Richard N. Stone; Mrs. George O. Tapley;
Mrs. Charles Taylor; Elizabeth Thacher; *Mrs. Dorothy Ashe
Thompson; *John H. Thompson; *Mrs. Bayard Trumbull; Prof.
Russell Twiggs; Stockton H. Tyler, Jr.; Mrs. William M. Weaver;
Stanley Weintraub; Ralph B. Whittier; *Mrs. Muriel Wilmott;
Mrs. Robert W. Wood; *Mrs. Marian B. Woods; *Dr. and Mrs.
R. L Wyatt; and *Mrs. Eustace Paul Ziegler.

I should like to express my appreciation to J. R. Wright not
only for typing the original version of the manuscript but also for
suggesting changes in the method of documentation and in the
format that have made the book easier to use.

And finally, I could not end without thanking Judith A.
Hoffberg, Executive Secretary of the Art Libraries Society of
North America—under whose auspices this volume is being
issued—and editor of the ARLIS/NA *Newsletter*. Immediately
and enthusiastically recognizing the usefulness of this work, she
helped to shape its final form and found a publisher for it. Who
could do more for an author?

INTRODUCTION

Several years ago, when I started trying to identify painters and sculptors mentioned by James Gibbons Huneker in critiques I had gathered for a collection of his writings on Americans in the arts, I discovered how poorly documented twentieth-century American art is. Many contemporary or near-contemporary artists are not listed in the standard reference books; or if they do appear in Bénézit, Fielding, Mallett, Smith, Vollmer, Thieme-Becker, Young, the *American Art Annual, Who's Who in American Art*, or elsewhere, the entries are often incorrect or incomplete, supplements notwithstanding. Birthdates, for example, are frequently missing, as some artists are reticent about revealing their age. Many deaths are not picked up in the *Art Index* or in the cumulative necrologies published in *Who's Who in American Art*; and even when they are, it is usually necessary to check several sources to obtain all the vital statistics on a recently deceased artist. It is virtually impossible to find *anything* in print about some obscure figures, and exceedingly difficult merely to learn the date and place of birth or death of better-known ones without consulting obituaries, necrologies, and vertical files in libraries—and then curious omissions persist: for example, I know of no reference book or any other publication generally available in America that records the death of Wilhelm Heinrich Funk, who died in Munich in 1949, or of Alexander Robinson, who died in France in 1952.

In the process of trying to identify artists for the Huneker book, I accumulated a list of names. To it I added those of artists associated with the MacDowell Colony whom I was attempting to trace in connection with another project I am working on: a biography of Mrs. Edward MacDowell, its founder. Many of these, I discovered, also were not in the reference books, or if they were, the entries were twenty or thirty years out of date. I have also

incorporated into this list a few names not related directly to the Huneker or MacDowell research that accounts for the bulk of the entries.

Most, but not all, of the artists I have listed were native-born or naturalized Americans; those who were not spent at least part of their creative life in this country, and most of them died here. Those who did not were expatriates such as Murray Bewley, Man Ray, and Alexander Robinson, all of whom died in France; Anglo-Americans such as John Mowbray-Clarke and John Singer Sargent, or English artists who came to America during World War II, such as Katherine and Reco Capey, all of whom died in England; and the Canadians Edith Macnee and Horatio Walker, who died in Canada, Charles Henry White, who died in France, and Donald Shaw MacLaughlan, who died in Morocco. A few artists were born in Europe in a city or town not indicated on their death certificates (when these are available) or recorded elsewhere; this is why the entries on Prosper Invernizzi and Abraham Levinson do not contain the city of birth. When an entry is incomplete, it is because my exhaustive attempts to obtain the information were fruitless.

Most of the dates that appear below have come from obituaries in newspapers and magazines or from reference books. I have attempted to verify, through the examination of birth or, more frequently, death records or through correspondence with the artists' families or friends, those dates that differ from the ones listed in the standard sources. But I have made no attempt to locate or examine the birth and death records of every artist, which would have been too costly and time-consuming—and, in some instances, impossible: some nineteenth-century births were never recorded, and some records have been lost. Most San Francisco birth records prior to 1906, for example, were destroyed in the earthquake of that year, as I discovered when trying to verify the birthdate of Julian W. Rix and Susan Watkins Serpell. All in all, I am more confident about the accuracy of the death than of the birth dates.

Difficulties in establishing birthdates spring partly from the reluctance of some artists to reveal their ages. They probably

ignored the item of age on questionnaires, or if they did supply it, they knocked off as many years as they dared. For example, Anna A. Hills, "Tony" Nell, Dorothy Rice, Florine Stettheimer, and Martha Walter (who lived to be 100, although no one could discover the fact from the reference books) invariably declined to furnish their age; and variants suggest that, unless these were all typographical errors, at some point in their life two years were deducted by Maurice Prendergast and Theodore Wores; three by Mary Aldis, John R. Koopman, Walt Kuhn, and Joseph Stella; seven by Helen F. Mears; and a whopping eight by Cecilia Beaux and Mary Fairchild Low. If the women artists were coyer about their age or bolder fibbers, no one on the list seems to have been as imaginative as Everett Shinn, who, over a period of six decades, became progressively younger, his year of birth being recorded as 1873 in 1917, 1876 in 1947, and 1878 in 1965. And did a desire to seem even more precocious account for the appearance in printed sources of the year of birth of the early blooming Miguel Covarrubias as 1902, 1904, and 1905, with the day and month accompanying only the latest year?

It wasn't always a matter of lying; sometimes variant dates were the result of honest mistakes. His wife tells me that Lee Gatch, who had always celebrated his birthday on September 10, was astonished to discover that according to his birth certificate, he was born on September 11; he continued to celebrate his birthday on the 10th but listed the 11th as the correct date. Likewise, John F. Carlson's family had always thought that he was born in 1875, but in response to my query, his son located a hundred-year-old document in Swedish that revealed that Carlson had actually been a year older. Had he himself known the fact? One would think that a single year would hardly be worth lying about.

Considering the ubiquity of human error in recording procedures, one is not always sure that even birth or death records are to be trusted completely. For example, the birthdate of the mysterious Patrick Henry Bruce appears as March 25, 1881, on his birth registration; yet the man who knows the most about him—Kenneth H. Cook—assures me that in an unpublished Bruce family genealogy now in his possession, the date appears as

March 21. Similarly, although the death certificate of Julian W. Rix states that when he died on November 24, 1903, he was fifty years and ten months old—which suggests that he had been born in late 1852 or early 1853—a published genealogy of the Rix family states that he was born on December 20, 1851. Which is right, the age on the death certificate—which doesn't contain the birthdate—or the date in the genealogy? Unfortunately, Vermont towns did not have to register vital statistics until later, and the entry could not be found in the state's birth records. And, again, although Frank Crane's birth record is available, it certifies that he was born on April 1, 1857, whereas on his death record and in a published genealogy of the Crane family, the day appears as April 2. Hence the question marks after all these dates.

Facts on birth and death records, moreover, sometimes conflict with those recorded in sources other than genealogies. For example, according to her death record, Mathilde de Cordoba died at age sixty-one. But the birthdate in the records of the hospital where she died—where the same month and day are found—would make her almost seventy-one. Because she herself probably gave the birthdate to the hospital, because the age mentioned in her obituary is seventy-one, and because her nearest surviving relative assures me she was closer to seventy-one than sixty-one, I am inclined to believe that the death record is wrong. And although Frank Crane's year of birth, according to his birth and death records and a family genealogy, was 1857, the superintendent of the cemetery where he is buried informs me that on his monument the dates read 1855-1917, whereas the cemetery's written records give his age as sixty. Did the engraver simply goof with the monument, or did he know something not found in the records?

My limited experience with census records suggests that they, too, sometimes reflect either the carelessness of the recorder or the vanity of the recordee. In the 1900 federal census, for example, not only was Kate Freeman Clark's last name spelled "Clarke" (a common enough error) but also her birthdate appears as "July 1879." Since this date did not jibe with the age mentioned in her obituary, I considered it questionable and tried other sources.

Sure enough, it turned out that in an entry in the remnants of a family Bible once owned by Miss Clark's grandmother and now deposited in her home town's historical society, her birthdate is recorded as September 7, 1875. Perhaps by 1900 the unmarried twenty-four-year-old—or her family—already feared the spinsterhood that a white lie, it developed, did not forestall.

Recorders, indeed, sometimes make rather obvious errors. For example, the birthdate on Arabella Wyant's death certificate, issued in 1919, is September 12, 1831 (although the careless clerk first wrote down the year as 1919); yet on the same certificate, her age is given as seventy-eight years, one month, and fourteen days—which means that she would have been born in 1841. As I discovered later, she gave birth to a son in 1883, which suggested that the later date was correct; this was eventually confirmed by her birth record. Similarly, Charles Henry White's age, at his death, is listed on his death registration as thirty-nine, but if his accepted birthdate is correct, it should have been forty. And the birthdate of George Gardner Symons—which appears in various reference books as 1861, 1863, and 1865—was first entered on his death record as what looks like October 29, 1862; this date was subsequently crossed out and replaced by October 27, 1861. All this makes one hesitate to put complete faith in recorded documents, welcome as they may be.

But family recollections which dredge up facts that conflict with those on official documents are not always more reliable. When I first wrote to Nathan Koffman's brother, he informed me that Nathan had been born in 1911. When I pointed out, shortly afterward, that the date appeared as 1910 in a book about his brother, he reiterated his belief that 1911 was the correct date. Only after I learned, and told him, that 1910 was the year unmistakably recorded in Philadelphia's birth records did he concede, graciously, that he must have been wrong.

Because there are far more discrepancies and uncertainties about birth than death dates, it is fortunate that the latter are the more useful; anyone desiring to learn more about a particular artist will be better able to commence his pursuit with a date of death—which can often lead to an obituary and further

information—than with a birthdate. Sometimes, however (though rarely), even the date of death varies in different accounts, usually by one day, as with Julian Rix. I have, I believe, resolved most or all of these discrepancies, but those dealing with two artists deserve special mention. Although at least three sources state that Patrick Henry Bruce died in 1937, he actually died in 1936. And George H. Bogert had the Twainian honor of being listed dead some twenty-one years before the news of his demise could be reported without "great exaggeration."

The reference books disagree on exact birthplaces, too, and death records are often useless here because the town or city is usually not required, only the state (and sometimes only the country). I don't know what his death record says, but both the New York *Times* and Fielding state that Charles W. Hawthorne was born in Maine, although they don't indicate the town, whereas an early *American Art Annual* lists his native state as Illinois; as far as I know, only the *National Cyclopaedia of American Biography* gives the exact birthplace as Lodi, Illinois. If the exact birthplace is provided, it is not always correct; for example, Alexander Robinson's death record, made out by French authorities, identifies his birthplace as Portsmouth, England, whereas it was actually Portsmouth, New Hampshire. The unlucky Philadelphia-native Nathan Koffman was, according to his New York death certificate, born in an unspecified place in Russia. And one of the most famous American sculptors, Gutzon Borglum, told so many conflicting stories abut his birthplace in pioneer territory that it is no wonder it appears as "Idaho" (no town) in his New York *Times* obituary; as "California" (no town) in Bénézit; and as "Idaho, California" in Vollmer. Both his and his brother's biographers got the exact place wrong, it seems, the former describing it as "Bear Lake, Idaho" (no such town exists) and the latter as "Ovid, Idaho." The truth, according to the Idaho State Historical Society, is that no one is sure about Borglum's birthplace, but it is *probably* accurate to say that he was born in St. Charles, Idaho.

These are some of the geographical pitfalls that keep vital statisticians from feeling too secure. When the birthplace I cite

differs from that found in some reference books, I have obtained it from records, relatives, or from some other indicated source that I consider more reliable, as the compilers of reference books often reproduce each other's errors.

One might think that the spelling of a well-known artist's name would offer few difficulties of identification, but even that can mislead the unwary researcher. That Borglum's name appears as "Borghum" in Mallett may be passed over as an unfortunate typographical error, but the case of John Mowbray-Clarke (with the troublesome hyphen that plagues indexers) requires fuller explanation. I first came across a reference to him when I happened to glance at a New York *Times* obituary of his wife, who was described therein as the widow of "the famous sculptor." For a famous sculptor, it was curious that his own obituary had not appeared in the *Times*, or anywhere else as far as I could discover, nor could I track down the son or two grandchildren mentioned in the widow's obituary. I did find an entry for him in *Who Was Who in America*, according to which he died on November 30, 1953, but the place of death was not indicated. Since the entry suggested that he had spent his last twenty-seven years in Oxford, England, I wrote the municipal authorities there for a death record. They replied that they could not find any under that name or any death notice in the local newspaper. About this time, the Whitney Museum of American Art, to which I had written for information about a number of artists including Mowbray-Clarke, informed me that they had a letter, dated 1963, that indicated that the sculptor had died in England "about 1958." More helpful was the 1963 address of Mowbray-Clarke's son, which they also sent me. I wrote him immediately, although not hopefully, because the address was now thirteen years old and because I had already checked the telephone book for that city and had found no Mowbray-Clarke listed. But fortunately, it turned out that although the son had died ten years earlier, *his* widow was still living at that address (unlisted in the telephone book), and she told me that the sculptor had indeed died on November 30, 1953, in Oxford.

Many years earlier, she explained, Mowbray-Clarke had fallen

in love with another woman and, when his wife refused to divorce him, had left the United States, gone to Canada, and eventually settled with this woman in England, where he lived in obscurity under the name of F. J. Clarke, losing all contact with his family. Sure enough, after I wrote again, Oxford came up with the record of death there of "F. J. Clarke." The mystery of the disappearance of Mowbray-Clarke was solved at last—and the hyphen, for once, was innocent

Most of my "cases" were not so dramatic, nor did they have such a "happy" ending. I did not, indeed, solve all the problems that started me off on this long job; I have still been unable to obtain the complete vital statistics of the following artists: Helen Dapprich; Laurence T. Dresser; Julius Golz, Jr.; Joseph Laub; George L. McKay; Olga Popoff Muller; Ivan Opffer; Hannibal Preziosi; Helen Ely Richardson; P. Scott Stafford; Ernest S. Trubach; or Winifred Ward. If any reader has any information about these artists other than that found in reference books— especially their date and place of death (if they are dead)— I hope he will pass it on to me.

It will surely be immediately obvious to any art librarian or other knowledgeable peruser of this list that it is relatively brief, highly selective, and heterogeneous, which is not surprising considering its origin and the focus of my interests. It includes both distinguished artists who are found in every art reference work (although almost never with all the data I present) and obscure, no doubt mediocre ones who are found in few, if any, sources. If such a resource had existed when I began my research on American artists, it would have saved me many, many hours of work. Perhaps it will do the same for others. It should, at any rate, be useful to art librarians, critics, and historians; potential biographers; museums; and dealers. It will, in a small way, complement the "Bicentennial Inventory of American Paintings Executed before 1914" now available at the Smithsonian Institution. I offer it as a modest contribution, in this Bicentennial year, to the up-to-date biographical dictionary of twentieth-century American artists that is so desperately needed.

Arnold T. Schwab
Long Beach, California
November 15, 1976

ABBREVIATIONS AND CODE

Letters

AAA	*American Art Annual*
B	Birth
Bén	Bénézit's *Dictionnaire critique et documentaire des Peintres, Sculpteurs, Dessinateurs et Graveurs*
C	Cartoonist
Ca	Caricaturist
CC	City or County Clerk (Registrar of Vital Statistics)
D	Death
DAB	*Dictionary of American Biography*
E	Engraver
Et	Etcher
F	Family of artist
Flg	Fielding's *Dictionary of American Painters, Sculptors, and Engravers*
Fr	Friend of artist
Hav	Patricia Pate Havlice's *Index to Artistic Biography*
HS	Historical Society
I	Illustrator
L	Lithographer
M	Medalist
Mal	*Mallett's Index of Artists*
NC	*National Cyclopaedia of American Biography*
NYC	New York City
NYT	New York *Times*
Ob	Obituary
P	Painter
Ph	Photographer
PL	Public Library
S	Sculptor
Smith	Ralph Clifton Smith's *A Biographical Index of American Artists* (Baltimore: Williams & Wilkins Co., 1930)

TC Town Clerk (Registrar of Vital Statistics)
Vol Vollmer's *Allgemeines Lexikon der Bildenden Künstler des XX. Jahrhunderts*
WA *Who's Who in American Art*
WWW Who Was Who in America

> The two-letter abbreviations for states follow those used in the *National Zip Code Directory* (U.S. Postal Service, 1975-1976).

Numbers

(1) *Who's Who in American Art* (New York: R. R. Bowker, 1935-)

(2) Arnold T. Schwab's correspondence with individuals and institutions. The institutions and some individuals are identified.

(3) *Who Was Who in America*, 5 vols. (Chicago: A. N. Marquis, 1943-1973)

(4) Mantle Fielding's *Dictionary of American Painters, Sculptors, and Engravers* (with addendum) (New York: James F. Carr, 1965)

(5) Municipal birth/death records of place of birth or death (or in community indicated)

(6) Daniel Trowbridge Mallett, *Mallett's Index of Artists* (1935; reprinted, New York: Peter Smith, 1948)

(7) *American Art Annual*, 37 vols. (Washington, D.C.: American Federation of Arts, 1898-1948)

(8) *National Cyclopaedia of American Biography* (New York: James T. White, 1891-)

(9) Hans Vollmer, ed., *Allgemeines Lexikon der Bildenden Künstler des XX. Jahrhunderts* (Leipzig: E. A. Seemann, 1953-1962)

(10) State birth/death records of place of birth or death

(11) E. Bénézit, ed., *Dictionnaire critique et documentaire des Peintres, Sculpteurs, Dessinateurs et Graveurs*, Nouvelle Edition (France: Librairie Gründ, 1960)

* Obituary or brief death notice appears in the New York *Times*.

EXPLANATION OF ANNOTATION

1. If an asterisked entry contains no other marking, it means that all items are taken from the New York *Times* obituary that appeared a day or two after the date of death. Delayed obituaries or those published elsewhere are cited in the Notes, together with news articles not indexed in the *New York Times Obituaries Index.*

2. If an asterisked entry contains a footnote number after any item, it means either that all the items except that one are taken from the New York *Times* obituary (the source of the footnoted item being indicated in the Notes) or that additional information regarding that item will be found in the Notes.

3. A footnote number immediately after the name of the artist means that all the items that follow come from the source cited in the Notes unless they are otherwise marked, or that a comment dealing with the entry as a whole will be found there. If other footnote numbers appear after any item within this entry, it means that either the source for that item or additional documentation will be found in the Notes.

4. If the only source available gives the birthplace as "N.Y." (not indicating whether city or state), the entry appears here as "New York? NY."

5. When I have actually seen a copy of the birth or death record, I list (5) or (10) as the source; when I have obtained the information through correspondence with an agency that checked the record for me but did not send me a copy, I cite (2) as the source, indicating the agency in the Notes.

6. When the same facts are provided in several sources, I cite *American Art Annual* or its successor, *Who's Who in American Art*, instead of Fielding or any other biographical dictionary; if the entry in Fielding, Bénézit, or Vollmer differs

from that in *AAA* or *WA*, I indicate at least one variant in the Notes but don't attempt to list them all.

7. First names in parentheses are those the artists did not use.

8. If the page number of a newspaper article—generally an obituary—was indicated in the copy sent to me, I include it; otherwise, only the date is provided.

9. To save space, "ibid." is used in the Notes—for consecutive entries from the same source—only if it is shorter than the full entry would be.

10. Since, for the sake of economy, only volume numbers, rather than dates or both, are given in the Notes for the frequently cited first four numbered volumes of *Who's Who in American Art*, the following table might be helpful:

Volume	Date
I	1936-1937
II	1938-1939
III	1940-1941
IV	1947

Subsequent volumes are not numbered.

A MATTER OF
LIFE AND DEATH

ARTIST'S NAME	BIRTHDATE	BIRTHPLACE	DEATHDATE	DEATHPLACE	AGE
		-A-			
*Abbey, Edwin A. (P)	Apr 1 1852	Philadelphia PA	Aug 1 1911	London England	59
*Adams, Herbert (S)	Jan 28[1] 1858	West Concord VT	May 21 1945	New York[2] NY	87
*Addams, Clifford Isaac (P)	May 25 1876	Woodbury NJ	Nov 6[3] 1942	New York NY	66
*Aitkin, Robert Ingersoll (S)	May 8[4] 1878	San Francisco CA	Jan 3 1949	New York NY	70
Aldis,[5] Mary (P)	Jun 8 1869	Chicago IL	Jun 20 1949	Wauwatosa WI	81
Alexander, John W. (P)	Oct 7 1856	Allegheny PA	May 31 1915	New York NY	58
*Anderson, Karl (P)	Jan 13[6] 1874	Oxford[6] OH	May 18 1956	Westport CT	82
*Anderson, Tennessee Mitchell (S)	Apr 18[7] 1874	Jackson[8] MI	Dec 20[7] 1929	Chicago IL	55
*Anshutz, Thomas Pollock (P)	Oct 5[9] 1851	Newport[9] KY	Jun 16 1912	Fort Washington PA	60
Ashe,[10] Edmund Marion (P)	Jun 19[11] 1867	New York NY	May 21[12] 1942	Charleston SC	74
*Auerbach-Levy, William (P,Ca)	Feb 14[13] 1889	Brest-Litovsk Russia	Jun 29 1964	Ossining NY	75
		-B-			
*Baer, William Jacob (P)	Jan 29[1] 1860	Cincinnati[1] OH	Sep 21 1941	East Orange NJ	81
*Baker, Martha Susan (P)	Dec 25[2] 1871	Evansville[2] IN	Dec 21 1911	Chicago IL	39
*Ball, Caroline Peddle (S)	Nov 11[3] 1869	Terre Haute[4] IN	Oct 1 1938	Torrington CT	68
*Ballin, Hugo (P)	Mar 7[5] 1879	New York[5] NY	Nov 27 1956	Santa Monica CA	76
Bannon,[6] Laura (P,I)	Jun 25 1894	Traverse City MT	Dec 13 1963	Roswell NM	69

ARTIST'S NAME	BIRTHDATE	BIRTHPLACE	DEATHDATE	DEATHPLACE	AGE
*Barjansky, Catherina (P)	Jan 20[7] 1890	Odessa Russia	Feb 6 1965	New York NY	75
*Barnard, George G. (S)	May 24 1863	Bellefonte PA	Apr 24 1938	New York NY	74
*Barone, Antonio (P)	May 20[8] 1889	Valledolmo[8] Sicily	Jan 15 1971	New York NY	81
*Barton, Ralph (Ca,I)	Aug 14 1891	Kansas City MO	May 20 1931	New York NY	39
*Beach, Chester (S)	May 23[9] 1881	San Francisco[10] CA	Aug 7 1956	Brewster NY	75
*Beal, Clifford Reynolds (P)	Jan 24[11] 1879	New York NY	Feb 5 1956	New York NY	77
*Beal, Reynolds (P,Et)	Oct 11[12] 1867	New York[12] NY	Dec 18 1951	Rockport MA	84
*Beatty, John Wesley (P)	Jul 8[13] 1851	Pittsburgh[14] PA	Sep 29 1924	Clifton Springs NY	74
*Beaux, Cecelia (P)	May 1[15] 1855	Philadelphia PA	Sep 17 1942	Eastern Point MA	87
*Beckett, Marion H. (P)	Feb 7[16] 1886	New York?[16] NY	Oct 10 1949	New York NY	63
*Beckington, Alice (P)	July 30[17] 1868	St. Louis MO	Jan 4 1942	La Jolla CA	73
*Beckwith, (James) Carroll (P)	Sep 23 1852	Hannibal MO	Oct 24 1917	New York NY	65
*Belcher, Hilda (P)	Aug 20[18] 1881	Pittsford[18] VT	Apr 26 1963	Orangw NJ	81[18]
*Bellows, George Wesley (P)	Aug 12 1882	Columbus OH	Jan 8 1925	New York NY	42
*Benson, Frank Weston (P,Et)	Mar 24[19] 1862	Salem MA	Nov 14 1951	Salem MA	89
*Benziger, August (P)	Jan 2[20] 1867	Einsiedeln Switzerland	Apr 13 1955	New York NY	88
*Berneker, Louis Frederick (P,Et)	Aug 29[21] 1872	Clinton MO	Jan 27 1937	Gloucester MA	64[21]

2

ARTIST'S NAME	BIRTHDATE	BIRTHPLACE	DEATHDATE	DEATHPLACE	AGE
Bewley,[22] Murray Percival (P)	Jun 19 1884	Fort Worth TX	Sep 3 1964	Nice France	80
Bicknell,[23] Frank Alfred (P)	Feb 17 1886	Augusta ME	Apr 7 1943	Old Lyme CT	77
*Biddle, George (P)	Jan 24 1885	Philadelphia PA	Nov 6 1973	Croton-on-Hudson NY	88
*Bitter, Karl (S)	Dec 6 1867	Vienna[24] Austria	Apr 10 1915	New York NY	47
Bittinger, Charles (P)	Jun 27[25] 1879	Washington[25] DC	Dec 18[26] 1970	Washington[26] DC	91
Blanke,[27] Marie Elsa (P)	May 24 1886	Chicago IL	Sep 2 1961	Bellows Falls VT	75
*Blashfield, Howland Edwin (P,I)	Dec 15[28] 1848	New York NY	Oct 12 1936	South Dennis MA	87
Blashki,[29] Miles Evergood (P)	Apr 10[30] 1871	Melbourne Australia	Jan 3 1939	Melbourne Australia	67
*Bluemner, Oscar Florianus (P)	Jun 21[31] 1867	Hanover Germany	Jan 12 1938	Braintree MA	70
*Blum, Jerome (P)	Mar 29[32] 1884	Chicago IL	Jul 23 1956	Poughkeepsie NY	82
*Bogert, George Hirst (P)	Feb 6[33] 1864	New York NY	Dec 13[34] 1944	New York NY	80
*Bohm, Max (P)	Jan 21[35] 1868	Cleveland[36] OH	Sep 19 1923	Provincetown MA	55
*Borglum, Gutzon (S)	Mar 25 1871	St. Charles[37] ID	Mar 6 1941	Chicago IL	69
*Borglum Solon H. (S)	Dec 22 1868	Ogden UT	Jan 30 1922	Stamford CT	53
*Borie, Adolphe (P)	Jan 5[38] 1877	Philadelphia PA	May 14 1934	Philadelphia PA	57
*Bosley, Frederick A. (P)	Feb 24[39] 1881	Lebanon[39] NH	Mar 22 1942	Concord MA	61
Boss,[40] Homer (P)	Jul 9[41] 1882	Blanchford MA	Jan 15 1956	Santa Cruz NM	73

3

ARTIST'S NAME	BIRTHDATE	BIRTHPLACE	DEATHDATE	DEATHPLACE	AGE
*Boyle, John J. (S)	Jan 12[42] 1852	New York NY	Feb 10 1917	New York NY	66
*Brenner, Victor David (M,S)	Jun 12[43] 1871	Shavely Russia	Apr 15 1924	New York NY	52
*Brewer, Ethelyn (P) (Mrs. Louis DeFoe)	Jun 16[44] 1876	Brooklyn NY	Apr 27 1928	New York NY	51
*Brewster,[45] Achsah (P)	Nov 12 1878	New Haven CT	Feb 16 1945	Almora India	66
Brewster,[46] Earl H. (P)	Sep 21 1878	Chagrin Falls OH	Sep 19 1957	Almora India	78
*Brinley, Daniel P. (P)	Mar 8[47] 1879	Newport[47] RI	Jul 30 1963	Norwalk CT	84
Brooks,[48] Romaine (P)	May 1 1874	Rome Italy	Dec 7 1970	Nice France	96
*Brown, John G. [George] (P)	Nov 11[49] 1831	Durham England	Feb 8 1913	New York NY	81
*Browne, George Elmer (P)	May 6[50] 1871	Gloucester MA	Jul 13 1946	Provincetown MA	75
*Browne, Matilda (P,I) (Mrs. Frederick Van Wyck)	May 8[51] 1869	Newark NJ	Nov 3 1947	Greenwich CT	78
Brownell,[52] Matilda A. (P)	Oct 19 1871	New York? NY	Sep 29 1966	Clinton NY	95
*Bruce, Patrick Henry (P)	Mar 21?[53] 1881	Halifax Co. VA	Nov 12 1936	New York[54] NY	55
*Brush, George De Forest (P)	Sep 28[55] 1855	Shelbyville[55] TN	Apr 24 1941	Hanover NH	85
*Burchfield, Charles Ephraim (P)	Apr 9 1893	Ashtabula OH	Jan 10 1967	Gardenville NY	73
*Burroughs, Bryson (P)	Sep 8[56] 1869	Hyde Park[56] MA	Nov 16 1934	New York NY	65
*Bush-Brown, Henry Kirke (S)	Apr 21[57] 1857	Ogdensburg[58] NY	Feb 28 1935	Washington DC	77[5]

4

ARTIST'S NAME	BIRTHDATE	BIRTHPLACE	DEATHDATE	DEATHPLACE	AGE
*Bush-Brown, Margaret Leslie (P)	May 19[59] 1857	Philadelphia PA	Nov 6 1944	Ambler PA	87
*Butler, Howard Russell (P)	Mar 3[60] 1856	New York? NY	May 22 1934	Princeton NJ	78

-C-

ARTIST'S NAME	BIRTHDATE	BIRTHPLACE	DEATHDATE	DEATHPLACE	AGE
*Calder, Alexander (S)	Jul 22 1898	Lawnton PA	Nov 11 1976	New York NY	78
*Calder, A. [Alexander] Stirling (S)	Jan 11 1870	Philadelphia PA	Jan 6 1945	New York NY	74
*Calverley, Charles (S)	Nov 1 1833	Albany NY	Feb 25 1914	Essex Falls NJ	80
Capey,[1] Katherine Bertram (P)	Jan 21 1908	Wellington Salop England	Apr 29 1971	Kingston England	63
Capey,[2] Reco (P)	Jul 5 1895	Smallthorn Staffs., England	May 11 1961	Alfriston, Sussex, England	65
*Carles, Arthur Bucher (P)	Mar 9[3] 1882	Philadelphia PA	Jun 19 1952	Philadelphia PA	70
*Carlisle, Mary Helen (P)	Nov 20[4] 1869	Grahamstown South Africa	Mar 17 1925	New York NY	55
*Carlsen, Emil (P)	Oct 19[5] 1853	Copenhagen Denmark	Jan 2 1932	New York NY	78
*Carlson,[6] John F. (P)	May 4 1874	Kolsebro Sweden	Mar 20 1945	New York NY	70
*Cassatt,[7] Mary (P)	May 22 1844	Allegheny City PA	Jun 14 1926	Mesnil-Theribus Oise, France	82
*Cauldwell, Leslie G. (P)	Oct 18[8] 1861	New York NY	Apr 9 1941	Paris France	79
Cederquist,[9] Arthur E. (P)	Apr 3 1884	Titusville PA	May 8 1954	North Warren PA	70
Chadwick, Grace W. (P)	Feb 25[10] 1893	Craig[11] MO	Jul 19[12] 1962	Oklahoma City OK	69
*Chaffee, Oliver Newberry (P)	Jan 23[13] 1881	Detroit[14] MI	Apr 25 1944	Asheville NC	63

ARTIST'S NAME	BIRTHDATE	BIRTHPLACE	DEATHDATE	DEATHPLACE	AGE
Chamberlin,[15] Frank Tolles (P)	Mar 10 1873	San Francisco CA	Jul 24 1961	Pasadena CA	88
Chaney,[16] Ruth Lucille (P)	Dec 26 1910	Kansas City MO	Oct 11 1966	Newton MA	55
*Chapman, Carlton T. (P)	Sep 18 1860	New London OH	Feb 12 1925	New York NY	64
*Chase, William Merritt (P)	Nov 1[17] 1849	Franklin IN	Oct 25 1916	New York NY	66
*Chatterton, C.[Clarence] K. (P)	Sep 19[18] 1880	Newburgh[18] NY	Jul 1 1973	New Peltz NY	92
*Child, Edwin Burrage (P)	May 29[19] 1868	Gouverneur[19] NY	Mar 10 1937	Dorset VT	68
*Christy, Howard C. (P)	Jan 10 1873	Morgan County OH	Mar 3 1952	New York NY	79
*Church, F. Edwin (P)	Oct 25[20] 1876	Brooklyn NY	July 15 1975	Locust Valley NY	98
*Church, Frederick Stuart (P,I)	Dec 1[21] 1842	Grand Rapids MI	Feb 18 1924	New York NY	81
*Churchill, Alfred Vance (P)	Aug 14[22] 1864	Oberlin OH	Dec 29 1949	Northampton MA	85
*Cimiotti, Gustave (P)	Nov 10 1875	Verona[23] Italy	Jan 19 1969	New York NY	93
*Clark, Guy Gayler (P)	Aug 26[24] 1882	Brooklyn[24] NY	Apr 16 1945	Upper Montclair NJ	62
Clark,[25] Kate Freeman (P)	Sep 7[26] 1875	Holly Springs MS	Mar 3 1957	Holly Springs MS	81
*Clews, Henry, Jr. (S)	Apr 23[27] 1876	New York NY	Jul 28 1937	Lausanne Switzerland	61
Cockcroft,[28] Edith V. (P) (Mrs. Charles L. Weyand)	Feb 6 1881	Brooklyn NY	Oct 19 1962	Ramapo NY	81
*Coffin, William Anderson (P)	Jan 31[29] 1855	Allegheny PA	Oct 26 1925	New York NY	70

ARTIST'S NAME	BIRTHDATE	BIRTHPLACE	DEATHDATE	DEATHPLACE	AGE
*Cohen, Lewis (P)	Jun 27[30] 1857	London England	Aug 4 1915	New York NY	58
*Cole, Timothy (E)	Apr 6[31] 1852	London England	May 17 1931	Poughkeepsie NY	79
*Coleman, Glenn O. (P)	Jul 18[32] 1887	Springfield OH	May 8 1932	Long Beach NY	48
*Coman, Charlotte Buell (P)	Nov 28[33] 1833	Waterville[34] NY	Nov 11 1924	Yonkers NY	90
*Connah, Douglas J. (P)	Apr 20 1871	New York NY	Aug 23 1941	New York NY	70
*Cooper, Colin Campbell (P)	Mar 8[35] 1856	Philadelphia PA	Nov 6 1937	Santa Barbara CA	81
*Cornoyer, Paul (P)	Aug 15[36] 1864	St. Louis MO	Jun 17 1923	East Gloucester MA	58
*Couse, E.[Eanger]Irving (P)	Sep 3[37] 1866	Saginaw MI	Apr 25 1936	Albuquerque NM	70
*Covarrubias, Miguel (P,Ca,I)	Nov 22[38] 1904	Mexico City Mexico	Feb 4 1957	Mexico City Mexico	52[39]
*Cox, Kenyon (P)	Oct 27 1856	Warren OH	Mar 17 1919	New York NY	62
*Cox, Louise (P) (Mrs. Kenyon Cox)	Jun 23[40] 1865	San Francisco[40] CA	Dec 11 1945	Windham CT	80
Cox-McCormack,[41] Nancy (S) (Mrs. Charles T. Cushman)	Aug 15[42] 1885	Nashville TN	Feb 17 1967	Ithaca NY	81
*Crane, (Robert)Bruce (P)	Oct 17[43] 1857	New York NY	Oct 29 1937	Bronxsville NY	80
*Crane (Louis)Frank (P,C,I)	Apr 2?[44] 1857	Woodbridge[45] NJ	Oct 26 1917	New Rochelle NY	60
*Culin, Alice Mumford (P)	(see "Roberts")				
Cuming,[46] Beatrice (P)	Mar 25[47] 1903	Brooklyn[47] NY	Mar 25 1974	Montville CT	71

7

ARTIST'S NAME	BIRTHDATE	BIRTHPLACE	DEATHDATE	DEATHPLACE	AGE
*Cunningham, Imogen (Ph) (Mrs. Roi Partridge)	April 12 1883	Portland OR	Jun 24 1976	San Francisco CA	93
*Curran, Charles Courtenay (P)	Feb 13[48] 1861	Hartford[48] KY	Nov 9 1942	New York NY	81

-D-

*Dabo, Leon (P)	Jul 9[1] 1868	Detroit MI	Nov 7 1960	New York NY	92
*Daniel, Lewis C. (I,Et,P)	Oct 23[2] 1901	New York? NY	Jul 18 1952	Near Brookville IL	50
*Davey, Randall (P)	May 24[3] 1887	East Orange[3] NJ	Nov 7 1964	Baker CA	76
*Davies, Arthur Bowen (P)	Sep 26[4] 1862	Utica NY	Oct 24 1928	Florence[4] Italy	66
*Davis, Helen Stuart Fulke (S)	Mar 11[5] 1869	Philadelphia PA	Oct 22 1965	Gloucester MA	96
*Davis, Stuart (P,I)	Dec 7 1894	Philadelphia PA	Jun 24 1964	New York NY	69
*Davol,[6] Joseph B. (P)	Aug 25[7] 1864	Chicago IL	Jun 15[8] 1923	Ogunquit ME	57
*Dearth, Henry Gordon (P)	Apr 22[9] 1864	Bristol RI	Mar 27 1918	New York NY	53
*De Camp, Joseph Rodefer (P)	Nov 5[10] 1858	Cincinnati OH	Feb 11 1923	Boca Grande FL	64
*De Cordoba,[11] Mathilde (P)	Aug 29[12] 1871	New York NY	Jul 1 1942	Valhalla NY	70[12]
*De Foe, Ethelyn Brewer (P)	(see "Brewer")				
*De Haven, Franklin (P)	Oct 26 1856	Bluffton IN	Jan 10 1934	New York NY	77
Deines,[13] E. [Ernest] Hubert(E,I)	Mar 29 1894	Russell KS	Jul 2 1967	Russell KS	73
*Demuth, Charles (P)	Nov 8[14] 1883	Lancaster PA	Oct 23 1935	Lancaster PA	51

8

ARTIST'S NAME	BIRTHDATE	BIRTHPLACE	DEATHDATE	DEATHPLACE	AGE
*Dewey, Charles Melville (P)	Jul 16[15] 1849	Lowville[15] NY	Jan 17 1937	New York NY	87
*Dewing, Thomas Wilmer (P)	May 4[16] 1851	Boston[16] MA	Nov 5 1938	New York NY	87
De Zayas,[17] Marius (P,Ca)	Mar 13 1880	Vera Cruz Mexico	Jan 10 1961	Stamford CT	80
*Dielman, Frederick (P)	Dec 25 1847	Hanover Germany	Aug 15 1935	Ridgefield CT	87
*Dimock, Edith (P) (Mrs. William Glackens)	Feb 16[18] 1876	Hartford[18] CT	Oct 28 1955	Hartford CT	79
*Dirks, Rudolph (C)	Feb 26 1877	Heide Germany	Apr 20 1968	New York NY	91
*Djeneeff, Ivan Alexeevich (P)	Sep 8[19] 1868	Kharkov[20] Russia	Jun 12 1955	New York NY	86
*Dodge, Ozias (Et)	Feb 16[21] 1868	Morrisville[22] VT	Jun 28 1925	Norwichtown CT	57
Dougherty, Parke Custis (P)	Aug 11[23] 1867	Philadelphia[23] PA	Apr 21[24] 1926	Philadelphia PA	58
*Dougherty, Paul (P)	Sep 6[25] 1877	Brooklyn NY	Jan 9 1947	Palm Springs CA	70
Douglas,[26] Laura Glenn (P)	Apr 26 1888	Winnsboro[27] SC	Dec 28 1962	Washington DC	74
Douglas,[28] Walter (P)	Jan 14 1868	Cincinnati OH	Aug 31 1948	Morristown NJ	80
*Dove, Arthur G. (P)	Aug 2[29] 1880	Canandaigua NY	Nov 23 1946	Huntington NY	66
*Dow, Arthur Wesley (P)	Apr 6[30] 1857	Ipswich MA	Dec 13 1922	New York NY	65
*Du Bois, Guy Pène (P)	Jan 4[31] 1884	Brooklyn[31] NY	July 18 1958	Boston MA	74
Dufner,[32] Edward (P)	Oct 5 1871	Buffalo NY	Oct 1 1957	Short Hills[33] NJ	85

9

ARTIST'S NAME	BIRTHDATE	BIRTHPLACE	DEATHDATE	DEATHPLACE	AGE
*Du Mond, Frank Vincent (P,I)	Aug 20[34] 1865	Rochester NY	Feb 6 1951	New York NY	85[34]
Dunton,[35] William Herbert (P)	Aug 28 1878	Augusta ME	Mar 18 1936	Taos NM	57
*Duveneck, Frank (P)	Oct 9[36] 1848	Covington KY	Jan 3 1919	Cincinnati OH	70
*Dwight, Mabel (P)	Jan 29[37] 1876	Cincinnati OH	Sep 4 1955	Sellersville PA	79
*Dyer, H. Anthony (P)	Oct 28[38] 1872	Providence[38] RI	Aug 24 1943	Providence RI	70

-E-

Eakins,[1] Thomas (P)	Jul 25 1844	Philadelphia PA	Jun 25 1916	Philadelphia[2] PA	71
*Eaton, Charles Warren (P)	Feb 22 1856	Albany NY	Sep 10 1937	Glen Ridge NJ	81
*Eberle, Abastenia St.Leger (S)	Apr 6[3] 1878	Webster City[3] IA	Feb 26 1942	New York NY	63
*Ebert, Charles H. (P)	Jul 20[4] 1873	Milwaukee[4] WI	Oct 2 1959	Old Lyme CT	86
*Edwards, George Wharton (P)	Mar 14[5] 1869	Fair Haven[5] CT	Jan 18 1950	Greenwich CT	81
*Eggleston, Benjamin O. (P)	Jan 22[6] 1867	Belvidere[6] MN	Feb 16 1937	Brooklyn NY	70
*Eilshemius, Louis Michel (P)	Feb 4[7] 1864	Arlington[7] NJ	Dec 29 1941	New York NY	77
*Emmet, Lydia Field (P)	Jan 23[8] 1866	New Rochelle[8] NY	Aug 16 1952	New York NY	86
*Ennis, George Pearse (P)	Jul 21[9] 1884	St. Louis MO	Aug 28 1936	Near Utica NY	52
*Epstein, Sir Jacob (S)	Nov 10 1880	New York NY	Aug 19 1959	London England	78
Evergood, Miles (P)	(see "Blashki")				

10

ARTIST'S NAME	BIRTHDATE	BIRTHPLACE	DEATHDATE	DEATHPLACE	AGE
		-F-			
*Faulkner, Barry (P)	Jul 12[1] 1881	Keene[1] NH	Oct 27 1966	Keene NH	85
*Faulkner, Herbert W. (P)	Oct 8 1860	Stamford CT	Mar 27 1940	Washington DC	79
*Feininger, Lyonel (P)	Jul 17 1871	New York[2] NY	Jan 13 1956	New York NY	84
*Fellows, Albert P. (P,Et)	May 27[3] 1864	Selma[4] AL	Nov 9 1940	Philadelphia PA	76
*Ferguson, Henry A. (P)	Jan 14[5] 1842	Glens Falls NY	Mar 22 1911	New York NY	69
*Field, Hamilton Easter (P,Et)	Apr 21[6] 1873	Brooklyn[6] NY	Apr 9 1922	Brooklyn NY	49
*Fisher, Anna S. (P)	Jul 26[7] 1873	Ohio[8] NY	Mar 18 1942	Cold Brook NY	69
*Flagg, Charles Noel (P)	Dec 25[9] 1848	Brooklyn NY	Nov 10 1916	Hartford CT	68
*Flanagan, John F. (S)	Apr 4[10] 1865	Newark[10] NJ	Mar 28[11] 1952	New York NY	86
*Fleming, Thomas (C)	Feb 25[12] 1853	Philadelphia[12] PA	Mar 4 1931	Maplewood NJ	78
Fletcher, Frank Morley (P)	Apr 25[13] 1866	Whiston[13] Lancashire England	Nov 2[14] 1949	Ventura[14] CA	83
*Foote, Will Howe (P)	Jun 29[15] 1874	Grand Rapids[15] MI	Jan 27 1965	Sarasota FL	90
*Ford, Lauren (P,Et,L)	Jan 23[16] 1891	New York? NY	Aug 30 1973	Waterbury CT	82
*Foster, Ben (P)	Jul 31[17] 1852	North Anson[17] ME	Jan 28 1926	New York NY	73
*Fowler, Frank (P)	Jul 12[18] 1852	Brooklyn[18] NY	Aug 18 1910	New Canaan CT	58
*Fraser, James Earle (S)	Nov 4 1876	Winona[19] MN	Oct 11 1953	Westport CT	76

11

ARTIST'S NAME	BIRTHDATE	BIRTHPLACE	DEATHDATE	DEATHPLACE	AGE
*Fraser, Laura Gardin (S,M)	Sep 14[20] 1889	Chicago[20] IL	Aug 13 1966	Norwalk CT	77
*French, Daniel Chester (S)	Apr 20 1850	Exeter[21] NH	Oct 7 1931	Stockbridge MA	81
*Friedman, Arnold Aaron (P)	Feb 23[22] 1873	New York NY	Dec 29 1946	Corona NY	73[2]
*Frieseke, Frederick Carl (P)	Apr 7 1874	Owosso MI	Aug 27 1939	Mesnil-sur-Blangy France	65
*Frisch, (Carl) Henry (P)	Mar 28[24] 1882	Richmond[24] Surrey, England	May 19 1934	New York NY	52
*Frisch, Victor (S)	May 1 1876	Vienna Austria	Oct 10 1939	New York NY	63
*Fromkes, Maurice (P)	Feb 19[25] 1872	Vilna Russia	Sep 17 1931	Paris France	59
*Fromuth, Charles H. (P)	Feb 23[26] 1861	Philadelphia PA	Jun 7 1937	Concarneau France	76
*Frost, Arthur Burdett (I)	Jan 17[27] 1851	Philadelphia PA	Jun 22 1928	Pasadena CA	77
*Frueh, Albert J. (Ca)	Sep 2[28] 1880	Lima[28] OH	Sep 14 1968	Sharon CT	88
*Fry, Mrs. Georgiana Timken (P)	Feb 3[29] 1864	St. Louis[29] MO	Sep 8 1921	Peking China	57[2]
*Fry, John Henning (P)	Jul 7[30] 1860	Greene County[30] IN	Feb 24 1946	Greenwich CT	85
*Fuchs, Emil (P,S)	Aug 9 1866	Vienna Austria	Jan 13 1929	New York NY	62
*Fuhr, Ernest (P,I)	May 3[31] 1874	New York NY	Dec 12 1933	Westport CT	59
*Fuller, Lucia Fairchild (P)	Dec 6[32] 1872	Boston[32] MA	May 21[33] 1924	Madison WI	51
Fuller,[34] Spencer (P)	Feb 25 1863	Deerfield MA	May 4 1911	Deerfield MA	48

12

ARTIST'S NAME	BIRTHDATE	BIRTHPLACE	DEATHDATE	DEATHPLACE	AGE
Funk, Wilhelm Heinrich (P)	Jan 14[35] 1866	Hanover[35] Germany	May 22[36] 1949	Munich[36] Germany	83

-G-

ARTIST'S NAME	BIRTHDATE	BIRTHPLACE	DEATHDATE	DEATHPLACE	AGE
*Gallatin, Albert Eugene (P)	Jul 23[1] 1881	Villanova PA	Jun 15 1952	New York NY	70
*Garber, Daniel (P)	Apr 11 1880	North Manchester IN	Jul 5 1958	Lumberville PA	78
Gaspard,[2] Leon (P)	Mar 2 1882	Vitebsk Russia	Feb 21 1964	Taos NM	81
*Gatch, (Harry) Lee (P)	Sep 11[3] 1902	Near Baltimore MD	Nov 10 1968	Trenton NJ	66
Gauley, Robert David (P)	Mar 12[4] 1871	Carneveigh[5] County Monoghan Ireland	Dec 31[6] 1943	Winter Park[6] FL	68
*Gay, Walter (P)	Jan 22[7] 1856	Hingham MA	Jul 14 1937	Chateau du Breau Seine-et-Marne France	81
*Genth, Lillian M. (P)	Jul 6[8] 1876	Philadelphia[8] PA	Mar 28 1953	New York NY	76
*Gilchrist, W. Wallace, Jr. (P)	Mar 2[9] 1879	Philadelphia PA	Nov 4 1926	Brunswick ME	47
*Glackens, William J. (P)	Mar 13 1870	Philadelphia PA	May 22 1938	Westport CT	68
*Glackens, Mrs. William J. (P)	(see "Dimock")				
*Glintenkamp, Hendrik (P,S,E,ET,I)	Sep 10[10] 1887	Augusta NJ	Mar 19 1946	New York NY	58
*Grafly, Charles (S)	Dec 3[11] 1862	Philadelphia PA	May 5 1929	Philadelphia PA	66
*Grant, Gordon (P,I)	Jun 7[12] 1875	San Francisco CA	May 7 1962	New York NY	86
*Granville-Smith Walter (P,I)	Jan 28 1870	South Granville NY	Dec 7 1938	Queens NY	68

13

ARTIST'S NAME	BIRTHDATE	BIRTHPLACE	DEATHDATE	DEATHPLACE	AGE
*Greacen, Edmund W. (P)	Sep 18[13] 1876	New York? NY	Oct 4 1949	White Plains NY	73[14]
*Groll, Albert L. (P,Et)	Dec 8 1866	New York? NY	Oct 2 1952	New York NY	85
*Gruger, Frederick Rodrigo (I)	Aug 3[15] 1871	Philadelphia PA	Mar 21 1953	New York NY	81[16]
*Gruppe, Charles Paul (P)	Sep 3[17] 1860	Picton[17] Canada	Sep 30 1940	Rockport MA	79
*Guerin, Jules (P,I)	Nov 18[18] 1866	St. Louis[18] MO	Jun]4 1946	Neptune NJ	79
*Guglielmi, Osvaldo Louis (P)	Apr 9[19] 1906	Cairo[19] Egypt	Sep 3 1956	Amagansett NY	50

-H-

ARTIST'S NAME	BIRTHDATE	BIRTHPLACE	DEATHDATE	DEATHPLACE	AGE
*Haggin, Ben Ali (P)	Apr 20[1] 1882	New York NY	Sep 2 1951	New York NY	69
*Halpert, Samuel (P)	Dec 25 1884	Bialystok[2] Russia	Apr 5 1930	Detroit MI	45
*Harris, William Laurel (P)	Feb 18[3] 1870	New York NY	Jul 31 1924	Lake George NY	54
*Harrison, Alexander (P)	Jan 17 1853	Philadelphia PA	Oct 13 1930	Paris France	77
*Harrison, (Lovell) Birge (P)	Oct 28[4] 1854	Philadelphia PA	May 11[5] 1929	Woodstock NY	74
*Hart, George O. (P,Et)	May 10 1868	Cairo IL	Sep 9 1933	New York NY	65
*Hartley, Jonathan Scott (S)	Sep 23 1845	Albany NY	Dec 6 1912	New York NY	67
*Hartley, Marsden (P)	Jan 4[6] 1877	Lewiston ME	Sep 2 1943	Ellsworth NE	66
Hartson,[7] Walter C. (P)	Oct 27[8] 1866	Wyoming[8] IA	Jul 19 1946	New Canaan CT	79
*Hassam, Childe (P)	Oct 17[9] 1859	Boston[9] MA	Aug 27 1935	East Hampton NY	75

ARTIST'S NAME	BIRTHDATE	BIRTHPLACE	DEATHDATE	DEATHPLACE	AGE
*Hawthorne, Charles Webster (P)	Jan 7[10] 1872	Lodi[10] IL	Nov 29 1930	Baltimore MD	58
*Hays, William Jacob, Jr, (P)	Jul 1[11] 1872	Catskill[11] NY	Sep 30 1934	Milbrook NY	62
*Hecht, Victor David (P)	May 15[12] 1873	Paris[12] France	Apr 15 1931	New York NY	57[12]
Heil, Charles E. (P)	Feb 28[13] 1870	Boston[13] MA	Apr 29[14] 1950	Boston MA	80
*Held, John, Jr. (I,C,P,S)	Jan 10[15] 1889	Salt Lake City UT	Mar 2 1958	Belmar NJ	69
*Henri, Robert (P)	June 24[16] 1865	Cincinnati OH	Jul 12 1929	New York NY	64
*Henry, Edward Lamson (P)	Jan 12[17] 1841	Charleston[17] SC	May 9 1919	Ellenville NY	78
*Herter, Albert (P)	Mar 2[18] 1871	New York[19] NY	Feb 15 1950	Santa Barbara CA	78
Hewes, Madeleine (P)	Jan 23[20] 1905	Baltimore MD	Aug 24 1969	Newtown[21] CT	64
*Higgins, Eugene (P,Et)	Feb 28[22] 1874	Kansas City[22] MO	Feb 19 1958	New York NY	83
*Hildebrandt, Howard Logan (P)	Nov 1[23] 1872	Allegheny[23] PA	Nov 11 1958	Stamford CT	84
Hill,[24] Clara L. (S)	Sep 25 1873	Boston MA	Jul 7 1935	Washington DC	61
Hills,[25] Anna Althea (P)	Jan 28 1882	Ravenna OH	Jun 13 1930	Laguna Beach Ca	48
Hobbs,[26] Morris Henry (P)	Jun 1[27] 1892	Rockford IL	Jan 24 1967	New Orleans[28] LA	74
*Hoeber (Hober), Arthur (P)	Jul 23[29] 1854	New York NY	Apr 29 1915	Nutley NJ	61
*Hoffman, Arnold (P)	Oct 15[30] 1886	Odessa Russia	Aug 21 1966	New York NY	80

15

ARTIST'S NAME	BIRTHDATE	BIRTHPLACE	DEATHDATE	DEATHPLACE	AGE
*Hoffman, Malvina (S) (Mrs. Samuel Bonarios Grimson)	Jun 15[31] 1885	New York NY	Jul 10 1966	New York NY	81
*Hofmann, Hans (P)	Mar 3[32] 1880	Weissenburg Germany	Feb 17 1966	New York NY	85
*Homer, Winslow (P)	Feb 24[33] 1836	Boston MA	Sep 29 1910	Scarboro ME	74
*Hopper, Edward (P)	Jul 22 1882	Nyack NY	May 15 1967	New York NY	84
*Hornby, Lester G. (P,I)	Mar 27[34] 1882	Lowell[34] MA	Dec 17 1955	Rockport MA	73
Horton,[35] Ruth Durland (P)	Mar 5 1894	Johnson NY	Jun 21 1960	Middleton NY	66
*Hubbell, Henry S. (P)	Dec 25[36] 1870	Paola KS	Jan 9 1949	Miami FL	78
Huggins,[37] Estelle Huntington (Ph)	Aug 28[38] 1867	Green Township Brown County OH	Dec 13 1963	Hillsboro OH	96
*Hyneman, Herman N. (P)	Jul 27[39] 1859	Philadelphia PA	Dec 23 1907	Philadelphia PA	58[40]

-I-

*Inness, George, Jr. (P)	Jan 5 1854	Paris France	July 27 1926	Cragsmoor NY	72
Invernizzi,[1] Prosper (P)	May 25 1875	Switzerland[2]	Jun 14 1942	New York NY	67
*Isham, Samuel (P)	May 12 1855	New York? NY	Jun 12 1914	Easthampton NY	59
*Ivanowski, Sigismund de (P,I)	Apr 17[3] 1874	Odessa Russia	Apr 12 1944	Westmoreland NH	69[4]

-J-

*Jaccaci, August Florian (P)	Jan 28 1856	Fontainbleau France	Jul 22 1930	Chateau Neuf-de-Grasse France	74

ARTIST'S NAME	BIRTHDATE	BIRTHPLACE	DEATHDATE	DEATHPLACE	AGE
*Jaegers, Albert (S)	Mar 28 1868	Elberfeld Germany	Jul 22 1925	Suffern NY	57
*Johansen, John Christen (P)	Nov 25[1] 1876	Copenhagen[1] Denmark	May 23 1964	New Canaan CT	88
*Johnson,[2] Content (P)	Oct 19[3] 1871	Bloomington IL	Nov 9 1949	Beverly Hills CA	78[4]
*Johnson, (Jonathan) Eastman (P)	Jul 29[5] 1824	Lovell[5] ME	Apr 5 1906	New York NY	81
*Jones, Francis Coates (P)	Jul 25[6] 1857	Baltimore[6] MD	May 27 1932	New York NY	74
*Jones, Hugh Bolton (P)	Oct 20 1848	Baltimore MD	Sep 24 1927	New York NY	78
*Josephi,[7] Isaac A. (P)	Dec 20 1859	New York NY	Jun 2 1954	New York NY	94

-K-

ARTIST'S NAME	BIRTHDATE	BIRTHPLACE	DEATHDATE	DEATHPLACE	AGE
*Kane, John (P)	Aug 19 1860	Near Edinburgh Scotland	Aug 10 1934	Pittsburgh PA	73[1]
*Karfiol, Bernard (P)	May 6[2] 1886	Budapest Hungary	Aug 16 1952	Irvington-on-Hudson NY	66
*Kaula, William Jurian (P)	Sep 18[3] 1871	Boston[3] MA	Jan 25 1953	Boston MA	81[4]
*Keith, William (P)	Nov 21[5] 1839	Old Meldrum[5] Aberdeenshire Scotland	Apr 13 1911	Berkeley CA	71
*Kendall, Beatrice (P)	Jan 14[6] 1902	New York NY	Oct 9[7] 1968	Vineyard Haven MA	66
*Kendall, (W.) Sergeant (P)	Jan 20 1869	Spuyten Duyvil NY	Feb 16 1938	Hot Springs VA	69
*Kent, Rockwell (P,I)	Jun 21 1882	Tarrytown Heights	Mar 13 1971	Plattsburgh NY	88
*King, Paul B. (P)	Feb 9[8] 1867	Buffalo NY	Nov 25 1947	New York NY	80

17

ARTIST'S NAME	BIRTHDATE	BIRTHPLACE	DEATHDATE	DEATHPLACE	AGE
*Knaths, (Otto) Karl (P)	Oct 21 1891	Eau Claire WI	Mar 9 1971	Hyannis MA	79[9]
Kobbé,[10] Marie Olga (P)	Jun 1[11] 1869	New Brighton NY	Apr 25 1947	New York NY	77
Koffman,[12] (Solis) Nathan (P)	Sep 28 1910	Philadelphia PA	Feb 18 1950	New York NY	39[1]
*Koopman, John R. (P)	Jun 17[14] 1878	Falmouth MI	Sep 16 1949	Saugerties NY	71[1]
Kremelberg,[16] Mary (P) (Mrs. Frederick Gibson)	1875?[17]	Baltimore MD	Jan 10 1946	Baltimore MD	70?
*Kroll, Leon (P)	Dec 6 1884	New York NY	Oct 25 1974	Gloucester MA	89
Kronberg, Louis (P)	Dec 20[18] 1872	Boston[18] MA	Mar 9[19] 1965	Palm Beach FL	93
*Kuhn, Walt (P)	Oct 27[20] 1877	New York NY	Jul 13 1949	White Plains NY	71

-L-

ARTIST'S NAME	BIRTHDATE	BIRTHPLACE	DEATHDATE	DEATHPLACE	AGE
*Lachaise, Gaston (S,P)	Mar 19[1] 1882	Paris[1] France	Oct 18 1935	New York NY	53
*Laessle, Albert (S)	Mar 28[2] 1877	Philadelphia PA	Sep 4 1954	Miami FL	77
*La Farge, John (P)	Mar 31[3] 1835	New York[3] NY	Nov 14 1910	Providence RI	75
Lambert,[4] John (P)	Mar 10 1861	Philadelphia PA	Dec 29 1907	Jenkintown PA	46
*Lathrop, William Langson (P)	Mar 29[5] 1859	Warren[5] IL	Sep 21 1938	Off Montauk· Point NY	79
*Lauber, Joseph (Et,S,P)	Aug 31[6] 1855	Meschede Westphalia Germany	Oct 18 1948	New York NY	93
*Lawson, Ernest (P)	Mar 22[7] 1873	San Francisco CA	Dec 18[8] 1939	Coral Gables FL	66

ARTIST'S NAME	BIRTHDATE	BIRTHPLACE	DEATHDATE	DEATHPLACE	AGE
*Lee, Arthur (S)	May 14[9] 1881	Trondheim Norway	May 14 1961	Newton CT	80
*Lever, (Richard) Hayley (P,Et)	Sep 28[10] 1866	Adelaide Australia	Dec 6 1958	Mt. Vernon NY	82
*Levinson, Abraham F. (P)	Aug 1 1883	Bessarabia[11] Russia	Jul 21 1946	Jamaica NY	62
Levy,[12] Alexander O. (P)	May 26 1881	Bonn Germany	Jan 21 1947	Buffalo[13] NY	65
*Lewis, Harold (P)	Mar 6[14] 1918	New York[14] NY	Aug 5 1971	Lancaster PA	53
*Lie, Jonas (P)	Apr 29 1880	Moss[15] Norway	Jan 10 1940	New York NY	59
*Linden,[16] Carl Olaf Eric (P)	Jun 1[17] 1869	Fellingsbro Sweden	Nov 7 1942	Woodstock NY	73
Link,[18] B. Lillian (S)	Jan 28 1880	New York NY	Nov 14 1963	Mystic CT	83
*Lippincott, William Henry (P)	Dec 6[19] 1849	Philadelphia PA	Mar 16 1920	New York NY	71
*Loeb, Louis (P)	Nov 7[20] 1866	Cleveland OH	July 12 1909	Canterbury NH	42
*Loomis, Chester (P)	Oct 18[21] 1852	Clay[22] NY	Nov 12 1924	Englewood NJ	72
*Loomis, William H. (C,I)	Nov 22[23] 1871	Providence RI	Nov 29 1917	New York NY	46[24]
Low, Mary Fairchild (P) (Mrs. Will H. Low)	Aug 11[25] 1858	New Haven CT	May 23[26] 1946	Bronxville[27] NY	87
*Low, Will Hicox (P)	May 31[28] 1853	Albany NY	Nov 27 1932	Bronxville NY	79
*Lukeman, Henry Augustus (S)	Jan 28[29] 1872	Richmond[29] VA	Apr 3 1935	New York NY	63
*Luks, George Benjamin (P)	Aug 13 1867	Williamsport PA	Oct 29 1933	New York NY	·66

19

ARTIST'S NAME	BIRTHDATE	BIRTHPLACE	DEATHDATE	DEATHPLACE	AGE
		-M-			
*Macdonald-Wright, Stanton (P)	Jul 8[1] 1890	Charlottesville[1] VA	Aug 22 1973	Pacific Palisades CA	83
*MacEwen, Walter (P,E)	Feb 13[2] 1860	Chicago IL	Mar 20 1943	New York NY	85
*MacLane, Jean (P)	Sep 14[3] 1878	Chicago IL	Jan 23 1964	Stamford CT	85
*MacLaughlin, Donald Shaw (Et)	Nov 9[4] 1876	Charlottown[5] Canada	Apr 18[6] 1938	Marrakesh Morocco	61[7]
*MacMonnies, Frederick William (S)	Sep 28[8] 1863	Brooklyn[8] NY	Mar 22 1937	New York NY	73
Macnee,[9] Edith M. (P)	May 6 1886	Glasgow[10] Scotland	Mar 16 1924	Yarmouth Nova Scotia Canada	37
*MacNeil, Hermon Atkins (S)	Feb 27[11] 1866	Chelsea MA	Oct 2 1947	Queens NY	81
*MacRae,[12] Elmer Livingston (P)	Jul 16 1875	New York NY	Apr 2 1953	Cos Cob CT	77
*Manigault, Edward M. (P)	Jun 14[13] 1887	London[14] Ontario Canada	Sep 5 1922	San Francisco CA	35[15]
*Manship, Paul (S)	Dec 25[16] 1885	St. Paul[16] MN	Jan 31 1966	New York NY	80
*Marin, John (P)	Dec 23 1872	Rutherford NJ	Oct 1 1953	Addison ME	80
*Marsh, Reginald (P)	Mar 14[17] 1898	Paris France	July 3 1954	Bennington VT	56
Martin,[18] Helen Smith (P) (Mrs. George Cushing Martin)	Aug 28 1879	De Kalb[19] IL	Oct 4 1965	Pasadena CA	86
*Martin, Homer D. (P,I)	Oct 28[20] 1836	Albany NY	Feb 12 1897	St. Paul MN	60
Mathewson,[21] Frank Converse (P)	May 12[22] 1862	Barrington RI	Dec 24 1941	Providence RI	79

ARTIST'S NAME	BIRTHDATE	BIRTHPLACE	DEATHDATE	DEATHPLACE	AGE
*Maurer, Alfred H. (P)	Apr 21[23] 1868	New York[23] NY	Aug 4 1932	New York NY	64
*Mayer, Henry ("Hy")(C)	Jul 18[24] 1868	Worms-on-Rhine[24] Germany	Sep 27 1954	South Norwalk CT	86
*McCartan, Edward (S)	Aug 16[25] 1879	Albany NY	Sep 20 1947	New Rochelle NY	68
*McCrea, Samuel Harkness (P)	Mar 15[26] 1867	Palatine[26] IL	Mar 28 1941	Darien CT	74
*McKenzie, R.[Robert] Tait (S)	May 26 1867	Almonte[27] Ontario, Canada	Apr 28 1938	Philadelphia PA	70
McLean,[28] Howard White (P)	Oct 24 1878	Vinton VA	Jan 19 1972	Middleton NJ	93
*Mears, Helen Farnsworth (S)	Dec 21[29] 1871	Oshkosh WI	Feb 17 1916	New York NY	44[30]
*Melchers, Gari (P)	Aug 11 1860	Detroit MI	Nov 30 1932	Falmouth VA	72
*Metcalf, Willard L. (P)	Jul 1[31] 1858	Lowell[31] MA	Mar 9 1925	New York NY	66[32]
*Mielatz, Charles Frederick (Et)	May 24[33] 1860	Breddin[33] Germany	Jun 2 1919	New York NY	59
*Miller, Kenneth Hayes (P,Et)	Mar 11[34] 1876	Oneida NY	Jan 1 1952	New York NY	75
*Miller Richard E. (P)	Mar 22[35] 1875	St. Louis[35] MO	Jan 13 1943	St. Augustine FL	67
*Millet,[36] Francis D. (P)	Nov 3 1946	Mattapoisett MA	Apr 15 1912	at sea	65
*Minor, Robert Crannell (P)	Apr 30[37] 1839	New York[37] NY	Aug 3 1904	Waterford CT	65
*Mitchell, John Ames (C)	Jan 17 1845	New York NY	Jun 29 1918	Ridgefield CT	73
Monoghan, Gertrude (P)	Jun 24[38] 1887	Westchester PA	Sep 7[39] 1962	Asheville[39] NC	75
*Moore,[40] (Thomas) Guernsey (P,I)	Feb 14[41] 1874	Germantown[42] PA	Jan 6 1925	Swarthmore[43] PA	50

ARTIST'S NAME	BIRTHDATE	BIRTHPLACE	DEATHDATE	DEATHPLACE	AGE
*Mora, F. Luis (P,I,Et)	Jul 27[44] 1874	Montevideo[45] Uruguay	Jun 5 1940	New York NY	65
*Moran, Thomas (P)	Jan 12 1837	Bolton England	Aug 26 1926	Santa Barbara CA	89
*Mosler, Gustave Henry (P)	Jun 16[46] 1875	Munich[46] Germany	Aug 17 1906	Margaretville NY	31
Mowbray-Clarke,[47] John F. (S)	Aug 4 1869	Jamaica West Indies	Nov 30 1953	Oxford[48] England	84
*Mulhaupt, Frederick John (P)	Mar 28[49] 1871	Rockport[49] MO	Jan 10 1938	Gloucester MA	66
*Muller-Ury, Adolph (P)	Mar 28[50] 1864	Airolo Switzerland	Jul 6 1947	New York NY	83
*Murphy, H. [Hermann] Dudley (P,I)	Aug 25[51] 1867	Marlboro MA	Apr 16 1945	Lexington MA	77
*Murphy, John Francis (P)	Dec 11 1853	Oswego NY	Jan 30 1921	New York NY	67
*Murray, Samuel (S)	Jun 12[52] 1870	Philadelphia[52] PA	Nov 3 1941	Philadelphia PA	71
*Myers, Jerome (P)	Mar 20[53] 1867	Petersburg VA	Jun 19 1940	New York NY	73

-N-

ARTIST'S NAME	BIRTHDATE	BIRTHPLACE	DEATHDATE	DEATHPLACE	AGE
*Nankivell, Frank Arthur (P,Et,C,I)	Nov 16[1] 1869	Maldon[1] Victoria Australia	Jul 3 1959	Morristown NJ	89
*Needham, Charles Austin (P)	Oct 30[2] 1844	Buffalo[2] NY	Nov 24 1922	Palenville NY	78
Nell,[3] Antonia ("Tony") (P)	Jan[4] 1881	Washington DC	Nov 24 1960	New York NY	79
*Newell, George Glenn (P)	May 11[5] 1870	Galien[5] MI	May 7 1947	Sharon CT	76[6]
*Nicholls, Rhoda Holmes (P)	Mar 28 1854	Coventry England	Sep 7 1930	Stamford CT	76
*Nichols, (Henry) Hobart (P)	May 1[7] 1869	Washington DC	Aug 14 1962	New York NY	93
*Nicoll, James C. (P,Et)	Nov 22 1847	New York NY	Jul 25 1918	Norwalk CT	70

22

ARTIST'S NAME	BIRTHDATE	BIRTHPLACE	DEATHDATE	DEATHPLACE	AGE
*Niehaus, Charles Henry (S)	Jan 24[8] 1855	Cincinnati[8] OH	Jun 19 1935	Cliffside Park NJ	80
*Niemeyer, John Henry (P)	Jun 25 1839	Bremen Germany	Dec 7 1932	New Haven CT	93
*Nisbet, Robert H. (P)	Aug 25[9] 1879	Providence RI	Apr 19 1961	South Kent CT	82
*Nixon, Wilson K. (P)	Nov 17[10] 1888	Chicago IL	Mar 29 1952	New York NY	63

–O–

ARTIST'S NAME	BIRTHDATE	BIRTHPLACE	DEATHDATE	DEATHPLACE	AGE
*Oberteuffer, George (P)	Oct 31[1] 1877	Philadelphia PA	May 13 1940	Gloucester MA	62
*Ochtman, Leonard (P)	Oct 21[2] 1854	Zonnemain[2] Holland	Oct 288 1934	Cos Cob CT	80
*O'Connor, Andrew, Jr. (S)	Jun 7[3] 1847	Worcester MA	Jun 11 1941	Dublin Ireland	67
*Olinsky, Ivan Gregorewitch (P)	Jan 1[4] 1878	Elizabethgrad[5] Russia	Feb 11 1962	New York NY	84
Otis, George Demont (P,E,L)	Sep 21[6] 1879	Memphis[6] TN	Feb 25[7] 1962	Kentfield[7] CA	82

–P–

ARTIST'S NAME	BIRTHDATE	BIRTHPLACE	DEATHDATE	DEATHPLACE	AGE
*Palmer, Walter Launt (P)	Aug 1 1854	Albany NY	Apr 16 1932	Albany NY	77[1]
*Parker, George Waller (P)	Sep 17[2] 1888	Gouverneur[2] NY	Jan 10 1957	New York NY	68
*Parker, Lawton S. (P)	Aug 7[3] 1868	Fairfield[4] MI	Sep 25 1954	Pasadena CA	86
*Parrish, Clara Weaver (P) (Mrs. William P. Parrish)	Mar 16[5] 1861	Selma AL	Nov 12 1925	New York NY	63
*Parrish, Maxfield (P,I)	Jul 25 1870	Philadelphia PA	Mar 30 1966	Plainfield NH	95
*Paxton, William M. (P)	Jun 22 1869	Baltimore MD	May 13 1941	Newton Center MA	72

23

ARTIST'S NAME	BIRTHDATE	BIRTHPLACE	DEATHDATE	DEATHPLACE	AGE
*Pearson, Joseph T., Jr.(P)	Feb 6 1876	Germantown PA	Feb 23 1951	Huntington Valley PA	75
Peirce, Dorothy Rice (P,S)	(see Rice, Dorothy)				
*Peirce, Waldo (P)	Dec 17[6] 1884	Bangor[6] ME	Mar 8 1970	Newburyport MA	85
*Peixotto, Ernest C. (P,I)	Oct 15 1869	San Francisco CA	Dec 6 1940	New York NY	71
*Penfield, Edward (I,P)	Jun 2 1866	Brooklyn NY	Feb 8 1925	Beacon NY	58
*Pennell, Joseph (E,P)	Jul 4[7] 1860	Philadelphia PA	Apr 23 1926	Brooklyn NY	65
*Perrine, Van D. (P)	Sep 10[8] 1869	Garnett KS	Dec 10 1955	Stamford CT	87
*Perry, Lila Cabot (P)	Jan 13[9] 1848	Boston[9] MA	Feb 28 1933	Hancock NH	85
*Perry, Roland Hinton (P)	Jan 25 1870	New York? NY	Oct 27 1941	New York NY	71
*Petersen, Martin (P)	Nov 23 1866	Vejle[10] Denmark	Nov 20 1956	New York NY	89
Peterson,[11] Jane (P) (Mrs. M. Bernard Philipp)	Nov 28 1876	Elgin IL	Aug 14 1965	Leawood KS	88
*Piccirilli, Attilio (S)	May 16[12] 1868	Massa Italy	Oct 8 1945	Bronx NY	77
Piccoli,[13] Girolamo (S)	May 9 1902	Palermo Italy	Nov 17 1971	Rome Italy	69
*Platt, Alethea Hill (P)	Dec 30[14] 1860	Scarsdale NY	May 24 1932	New York[15] NY	71
*Poore, Henry Rankin (P)	Mar 21 1859	Newark NJ	Aug 15 1940	Orange NJ	81
*Potter, Louis McClellan (S)	Nov 14 1873	Troy NY	Aug 29 1912	Seattle WA	38

ARTIST'S NAME	BIRTHDATE	BIRTHPLACE	DEATHDATE	DEATHPLACE	AGE
*Potthast, Edward H. (P)	Jun 11 1857	Cincinnati OH	Mar 10 1927	New York NY	69
*Potts, W. Sherman (P)	Jul 29 1876	Milburn NJ	Jun 16 1930	Stonington CT	53
*Pousette-Dart, Nathaniel J. (P)	Sep 7[16] 1886	St. Paul MN	Oct 17 1965	Valhalla NY	79
*Powers, Thomas E. (C)	Jul 4 1870	Milwaukee WI	Aug 14 1939	Long Beach NY	69
*Pratt, Bela Lyon (S)	Dec 11[17] 1867	Norwich[17] CT	May 18 1917	Boston MA	49
*Prellwitz, Edith Mitchill (P) (Mrs. Henry Prellwitz)	Jan 28[18] 1865	South Orange NJ	Aug 18 1944	East Greenwich RI	79
*Prendergast, Maurice Brazil (P)	Oct 10[19] 1859	St. Johns[20] Newfoundland Canada	Feb 1 1924	New York NY	64
*Preston, James Moore (P,I)	Feb 5 1873	Roxborough[21] PA	Jan 15 1962	Southhampton NY	88
*Proctor, Alexander P. (S)	Sep 27[22] 1860	Ontario Canada	Sep 5 1950	Palo Alto CA	88
*Pyle, Howard (P,I)	Mar 5[23] 1853)	Wilmington DE	Nov 9 1911	Florence Italy	58
		-Q-			
Quirt, Walter Wellington (P)	Nov 24[1] 1902	Iron River[1] MI	Mar 19[2] 1968	Minneapolis[2] MN	65
		-R-			
Ramsey, Milne (P)	Sep 16[1] 1846	Philadelphia[2] PA	Mar 16[3] 1915	Philadelphia[2] PA	68[3]
*Ranger, Henry Ward (P)	Jan 29?[4] 1858	Syracuse?[5] NY	Nov 7 1916	New York NY	58
*Redfield, Edward Willis (P)	Dec 18[6] 1869	Bridgeville[7] DE	Oct 19 1965	Center Bridge PA	95
*Rehn, Frank Knox Marton (P)	Apr 12[8] 1848	Philadelphia PA	Jul 6 1914	Magnolia MA	66

25

ARTIST'S NAME	BIRTHDATE	BIRTHPLACE	DEATHDATE	DEATHPLACE	AGE
*Reid, Robert (P)	Jul 29 1862	Stockbridge MA	Dec 2 1929	Clifton Springs NY	67
*Reinhart, Charles Stanley (P,I)	May 16 1844	Pittsburgh PA	Aug 30 1896	New York NY	52
*Remington, Frederic (S,Et,P,I)	Oct 4[9] 1861	Canton[9] NY	Dec 26 1909	Ridgefield CT	48
*Reuterdahl, Henry (P)	Aug 12[10] 1871	Malmö[10] Sweden	Dec 20 1925	Washington DC	54
*Reynard, Grant Tyson (P,Et)	Oct 20[11] 1887	Grand Island NE	Aug 13 1968	New York NY	80
*Rhoads, Katharine N. (P)	Jun 25[12] 1895	Richmond[13] VA	Jul 25 1938	Richmond VA	43
*Rice, Dorothy (P,S) (Mrs. P. Hal Sims)	Jun 24[14] 1889	Ashway Park[14] NJ	Mar 24 1960	Cairo Egypt	70
*Richardson, Mary Curtis (P)	Apr 9[15] 1848	New York NY	Nov 1 1931	San Francisco CA	83
*Ritschel, William (P)	Jul 11[16] 1864	Nuremberg[16] Germany	Mar 11 1949	Carmel Highlands CA	84
*Rittenberg, Henry R. (P)	Oct 2[17] 1879	Liepaja (Libau)[17] Russia	Aug 16 1969	New York NY	89
*Rix, Julian Walbridge (P)	Dec 20[18] 1851?	Peacham[19] VT	Nov 24 1903	New York NY	50[20]
*Roberts, Alice Mumford (P) (Mrs. Robert Stewart Culin)	Jan 30[21] 1875	Philadelphia[22] PA	Aug 8 1950	Miami[23] FL	75
Robinson, Alexander Charles (P)	May 11[24] 1867	Portsmouth[24] NH	May 27 1952	Cassis[25] France	85
*Robinson, Boardman (P,C,I)	Sep 6[26] 1876	Somerset Nova Scotia Canada	Sep 5 1952	Stamford CT	75
*Robinson, Florence Vincent (P)	Nov 18[27] 1874	Taunton?[28] MA	Mar 31[29] 1937	New York NY	62

ARTIST'S NAME	BIRTHDATE	BIRTHPLACE	DEATHDATE	DEATHPLACE	AGE
*Robinson, Theodore (P,I)	Jun 3[30] 1852	Irasburg[31] VT	Apr[32] 1896	New York NY	43
*Rolshoven, Julius (P)	Oct 28[33] 1858	Detroit MI	Dec 7 1930	New York NY	72
*Rook, Edward Francis (P)	Sep 21[34] 1870	New York[35] NY	Oct 25 1960	New London CT	90
Rose,[36] Guy (P,I)	Mar 3[37] 1867	San Gabriel CA	Nov 17 1925	Pasadena CA	58
*Rosen, Charles (P,I)	Apr 28[38] 1878	Westmoreland[38] County, PA	Jun 21 1950	Kingston NY	72
*Rosenthal, Albert (P,Et)	Jan 30[39] 1863	Philadelphia[39] PA	Dec 20 1939	New York NY	76
*Roth, Ernest David (P,Et)	Jan 17[40] 1879	Stuttgart[40] Germany	Aug 20 1964	Cambridge NY	85
*Rouland, Orlando (P)	Dec 21[41] 1871	Pleasant Ridge[41] IL	Jun 26 1945	New York NY	73
Rubins,[42] Harry W. (Et)	Nov 25 1865	Buffalo NY	Sep 8 1934	Minneapolis MN	68
*Ruckstull, Frederick Wellington (S)	May 22[43] 1853	Breitenbach[43] Alsace	May 26 1942	New York NY	89
*Russell, Charles Marion (P)	Mar 19[44] 1864	St. Louis MO	Oct 24 1926	Great Falls MT	62[45]
*Russell, Morgan (P)	Jan 25[46] 1886	New York?[46] NY	May 30 1953	Paoli[47] PA	67
*Ryder, Albert P. (P)	Mar 19 1847	New Bedford MA	Mar 28 1917	Elmhurst NY	70
*Ryder, Chauncey F. (P)	Feb 29[48] 1868	Danbury[48] CT	May 18 1949	Wilton NH	81

-S-

*Saint-Gaudens, Augustus (S)	Mar 1 1848	Dublin Ireland	Aug 3 1907	Cornish NH	59
Salko,[1] Samuel (P)	Feb 12[2] 1888	Genichesk[2] Russia	Apr 20[1] 1968	Philadelphia[1] PA	80

27

ARTIST'S NAME	BIRTHDATE	BIRTHPLACE	DEATHDATE	DEATHPLACE	AGE
*Sargent, John Singer (P)	Jan 12[3] 1856	Florence Italy	Apr 15 1925	London England	69
*Satterlee, Walter (P)	Jan 18[4] 1844	Brooklyn[4] NY	May 28 1908	New York NY	64[5]
Schille,[6] Alice O. (P)	Aug 21 1869	Columbus OH	Nov 6 1955	Columbus OH	86
*Schneider, Arthur Esslinger (P)	Sep 16 1865	Madison WI	Feb 7 1942	Tampa FL	76
*Schneider[7] William George (P)	Nov 14[8] 1863	Monroe[9] WI	Nov 5 1912	New York NY	48
*Schofield, Walter Elmer (P)	Sept 9[10] 1867	Philadelphia[10] PA	Mar 1 1944	Cornwall England	76[11]
*Schulman, Abram Gustave (P)	Jan 5[12] 1881	Königsberg[12] Germany	Jun 2 1935	Phoenix AZ	54
*Sears, Taber (P)	Feb 2[13] 1870	Boston MA	Oct 18 1950	New York NY	80
Selden, Dixie (P,I)	Feb 28[14] 1868	Cincinnati[14] OH	Nov 15[15] 1935	Cincinnati OH	67
*Senseney, George E. (Et)	Oct 11[16] 1874	Wheeling[16] WV	Nov 18 1943	Ipswich MA	69
Sewell, Lydia Amanda Brewster (P) (Mrs. Robert V.V.Sewell)	Feb 24[17] 1859	North Elba[17] NY	Nov 15[18] 1926	Florence[19] Italy	67
*Shaler, Frederick R. (P)	Dec 15[20] 1880	Findlay[20] OH	Dec 27 1916	Taormina Sicily	36[21]
*Shannon, Sir James Jebusa (P)	Feb 3[22] 1862	Auburn NY	Mar 6 1923	London England	61
*Sheeler, Charles R., Jr. (P)	Jul 16[23] 1883	Philadelphia[23] PA	May 7 1965	Dobbs Ferry NY	81
*Shinn, Everett (P,I)	Nov 6[24] 1876	Woodstown NJ	May 1 1953	New York NY	76
*Shirlaw, Walter (P)	Aug 6 1838	Paisley Scotland	Dec 26 1909	Madrid Spain	71

28

ARTIST'S NAME	BIRTHDATE	BIRTHPLACE	DEATHDATE	DEATHPLACE	AGE
*Shurtleff, Roswell Morse (P,I)	June 14[25] 1838	Rindge NH	Jan 6 1915	New York NY	76
*Simmons, Edward (P)	Oct 27[26] 1852	Concord[26] MA	Nov 17 1931	Baltimore MD	79
*Skidmore, Louis Palmer (P)	Sep 3[27] 1877	Bridgeport CT	Jun 10 1955	Dunwoody GA	77
*Sloan, John (P,Et,I)	Aug 2 1871	Rock Haven PA	Sep 8 1951	Hanover NH	80
*Smedley, William Thomas (P)	Mar 26[28] 1857	West Bradford[28] PA	Mar 26 1920	Bronxville NY	63[29]
*Smith, Albert Delmont (P)	Feb 14[30] 1886	New York[30] NY	Oct 2 1962	Lloyd Harbor NY	76
*Smith, (J) André (P,Et)	Dec 31[31] 1880	Hong Kong China	Mar 3 1959	Maitland Fl	79
*Smith Walter Granville (P,I) (see "Granville")					
*Snell, Henry Bayley (P)	Sep 29 1858	Richmond England	Jan 17 1943	New Hope PA	84
Sparhawk-Jones,[32] Elizabeth (P)	Nov 8 1885	Baltimore[33] MD	Dec 26 1968	Baltimore MD	83
*Speicher, Eugene (P)	Apr 5 1883	Buffalo NY	May 11 1962	Woodstock NY	79
*Spencer,[34] Robert (P)	Dec 1 1879	Harvard NE	Jul 11 1931	New Hope PA	51
Spicer-Simson, Margaret (Mrs. Theodore) (P)	Mar 6[35] 1874	Washington[35] DC	Apr 5[36] 1968	Miami[36] FL	94
Spicer-Simson,[37] Theodore (S,M)	Jun 25 1871	Le Havre France	Feb 1 1959	Miami[38] FL	87
*Sprinchorn, Carl (P)	May 13[39] 1887	Broby[39] Sweden	Sep 6 1971	Albany NY	84
Springweiler, Erwin F. (S)	Jan 10[40] 1896	Pforzheim[40] Germany	Mar 18[41] 1968	West Islip[42] NY	72
*Steichen, Edward J. (Ph)	Mar 27 1879	Bivenge[43] Luxembourg	Mar 25 1973	West Redding Ct	93

ARTIST'S NAME	BIRTHDATE	BIRTHPLACE	DEATHDATE	DEATHPLACE	AGE
*Stella, Joseph (P)	Jun 13[44] 1877	Muro Lucano[44] Italy	Nov 5 1948	Astoria Queens NY	69[45]
*Sterne, Maurice (P)	Aug 13[46] 1877	Liepaja (Libau) Russia	Jul 23 1957	Mt. Kisco NY	79
*Sterner, Albert (P,Et)	Mar 8[47] 1863	London England	Dec 16 1946	New York NY	83
*Stettheimer, Florine (P)	Aug 19[48] 1871	Rochester[48] NY	May 14 1944	New York NY	72
*Stieglitz, Alfred (Ph)	Jan 1[49] 1864	Hoboken NJ	Jul 13 1946	New York NY	82
*Stonehill, George (P)	Sep 28[50] 1887	Ionia MI[50]	May 6 1943	New York NY	55
*Stonehill,[51] Mary (Mrs. George) (P)	Oct 23[51] 1900	New York[51] NY	Feb 11 1951	New York NY	50
Stout Ida McClelland (S)	Jan 20[52] 1890	Decatur[53] IL	Sep 2[54] 1927	Rome[54] Italy	37
*Strand, Paul (Ph)	Oct 16 1890	New York NY	Mar 31 1976	Oregeval France	85
*Symons, George Gardner (P)	Oct 27[55] 1861	Chicago IL	Jan 12 1930	Hillside NJ	64

-T-

ARTIST'S NAME	BIRTHDATE	BIRTHPLACE	DEATHDATE	DEATHPLACE	AGE
*Tack, Augustus Vincent (P)	Nov 9[1] 1870	Pittsburgh[1] PA	Jul 20[2] 1940	Deerfield[3] MA	78
*Taft, Lorado (S)	Apr 29 1860	Elmwood[4] IL	Oct 30 1936	Chicago IL	76
*Tanner, Henry Ossawa (P)	Jun 21[5] 1859	Pittsburgh[5] PA	May 26[6] 1937	Paris France	78
*Tarbell, Edmund Charles (P)	Apr 26 1862	West Groton MA	Aug 1 1938	New Castle NH	76
Taylor, Anna Heyward (E,P)	Nov 13[7] 1879	Columbia[7] SC	Mar 4[8] 1956	Charleston[8] SC	76

30

ARTIST'S NAME	BIRTHDATE	BIRTHPLACE	DEATHDATE	DEATHPLACE	AGE
*Taylor, Emily Drayton (P) (Mrs. J. Madison Taylor)	Apr 14[9] 1860	Philadelphia[9] PA	Jun 19 1952	Philadelphia PA	92
*Taylor, Henry Fitch (P)	Sep 15[10] 1853	Cincinnati[10] OH	Sep 10 1925	Plainfield NH	71
*Thayer, Abbott Handerson (P)	Aug 12[11] 1849	Boston MA	May 29 1921	Dublin NH	71
Thayer, Gladys (P) (Mrs. David Reasoner)	Jul 17[12] 1886	South Woodstock[12] CT	Aug 25[13] 1945	Washington[13] DC	58
*Thompson,[14] Juliet Hutchings (P)	Sep 23 1873	New York NY	Dec 4 1956	New York NY	83
Thompson, Leslie Prince (P)	Mar 2[15] 1880	Medford MA	May 19[16] 1963	Newton Center[16] MA	83
Thompson,[17] Nellie Louise (P,I)	Sep 2 1861	Boston MA	Aug 31[18] 1935	Boston MA	73
Thouron, Henry J. (P)	Dec 25[19] 1852	Philadelphia[19] PA	Dec 12[20] 1915	Rome[20] Italy	62
*Tiffany, Louis Comfort (P)	Feb 18 1848	New York[21] NY	Jan 17 1933	New York NY	84
*Tobey, Mark (P)	Dec 11 1890	Centerville WI	Apr 24 1976	Basel Switzerland	85
*Tryon, Dwight W. (P)	Aug 13[22] 1849	Hartford CT	Jul 1 1925	South Dartmouth MA	75
*Tucker, Allen (P)	Jun 29[23] 1866	Brooklyn[23] NY	Jan 26 1939	New York NY	72
*Turner, Charles Yardley (P)	Nov 25 1830	Baltimore MD	Jan 1 1919	Baltimore MD	88
*Turner, Helen M. (P)	Nov 13[24] 1858	Louisville[24] KY	Jan 31 1958	New Orleans LA	99
*Turner, Ross S. (P)	Jun 29[25] 1847	Westport[25] NY	Feb 12 1915	Nassau Bahamas	67
*Twachtman, John H. (P)	Aug 4 1853	Cincinnati OH	Aug 8 1902	Gloucester MA	49

31

ARTIST'S NAME	BIRTHDATE	BIRTHPLACE	DEATHDATE	DEATHPLACE	AGE
*Tyson, Carroll Sargent, Jr., (P)	Nov 23[26] 1878	Philadelphia PA	Mar 19 1956	Philadelphia PA	78

<div align="center">-U-</div>

ARTIST'S NAME	BIRTHDATE	BIRTHPLACE	DEATHDATE	DEATHPLACE	AGE
*Ullman, Eugene Paul (P)	Mar 27[1] 1877	New York?[1] NY	Apr 20 1953	Paris France	76

<div align="center">-V-</div>

ARTIST'S NAME	BIRTHDATE	BIRTHPLACE	DEATHDATE	DEATHPLACE	AGE
*Van Boskerck, Robert W. (P)	Jan 15[1] 1855	Hoboken[1] NJ	Apr 24 1932	New York NY	77
*Vanderhoof, Charles A. (P,Et)	Jun 7[2] 1853	Locust Point[3] NJ	Apr 1 1918	Locust Point NJ	64
Van der Veer,[4] Mary (P)	Sep 9 1865	Fort Hunter NY	May 11 1945	Amsterdam NY	79
*Van Everen, Jay (P)	Nov 5[5] 1875	Mt. Vernon[5] NY	Dec 30 1947	Monterey MA	72
*Van Laer,[6] Alexander Theobald (P)	Feb 9[7] 1857	Auburn NY	Mar 12 1920	Indianapolis IN	62
*Vezin, Charles (P)	Apr 9 1858	Philadelphia PA	Mar 13 1942	Coral Gables FL	83
*Volk, (Stephen A.) Douglas (P)	Feb 23 1856	Pittsfield MA	Feb 7 1935	Fryeburg ME	79
Vondrous,[8] Jan C. (P,I,Et)	Jan 24 1884	Chotusice Bohemia	Jun 28[9] 1970	Prague Czechoslovakia	86
*Von Wicht, John (P)	Feb 3 1888	Schleswig-Holstein Germany	Jan 20 1970	Brooklyn NY	81

<div align="center">-W-</div>

ARTIST'S NAME	BIRTHDATE	BIRTHPLACE	DEATHDATE	DEATHPLACE	AGE
*Walker, Horatio (P)	May 12[1] 1858	Listowel[1] Ontario Canada	Sep 27 1938	St. Pétronille Ile d'Orléans	80
*Walkowitz, Abraham (P)	Mar 28[2] 1880	Tuiemen[2] Siberia Russia	Jan 26 1965	Brooklyn NY	84

ARTIST'S NAME	BIRTHDATE	BIRTHPLACE	DEATHDATE	DEATHPLACE	AGE
Walter,[3] Martha (P)	Mar 19[4] 1875	Philadelphia PA	Jan 18 1976	Moorestown NJ	100
*Walters, Carl (S)	Jun 19[5] 1883	Ft. Madison[5] IA	Nov 12 1955	Saugerties NY	72
*Warner, Everett L. (P,Et)	Jul 16[6] 1877	Vinton[6] IA	Oct 20 1963	Bellows Falls VT	86
*Warshawsky, Abel G. (P)	Dec 28[7] 1883	Sharon[7] PA	May 30 1962	Monterey CA	78
Watkins,[8] Susan (P) (Mrs. Goldsborough Serpell)	1875[9]	San Francisco[10] CA	Jun 18[11] 1913	Baltimore MD	37
*Watrous, Harry W. (P)	Sep 17 1857	San Francisco CA	May 9 1940	New York NY	82[12]
*Waugh, Frederick J. (P)	Sep 13 1861	Bordentown NJ	Sep 10 1940	Provincetown MA	78
*Weber, Max (P)	Apr 18[13] 1881	Bialystok[14] Russia	Oct 4 1961	Great Neck NY	80
*Weinman, Adolph Alexander (S)	Dec 11[15] 1870	Karlsruhe[15] Germany	Aug 9 1952	Port Chester NY	81
*Weir, Julian Alden (P,Et)	Aug 30[16] 1852	West Point NY	Dec 8 1919	New York NY	67
*Welch,[17] Mabel R. (P)	Mar 26 1871	New Haven CT	Jan 1 1959	West Springfield[18] MA	87
*Wheeler, Clifton A. (P)	Sep 4[19] 1883	Hadley[19] IN	May 10 1953	Indianapolis IN	69
*Whipple, Charles Ayer (P)	Feb 22[20] 1859	Southboro[20] MA	May 3 1928	Washington DC	69
*Whistler, James A. McNeill (P,Et)	Jul 11[21] 1834	Lowell MA	Jul 17 1903	London England	69
White,[22] Charles Henry (Et)	Apr 14[23] 1878	Hamilton Ontario Canada	Sep 13 1918	Nice France	40[24]

ARTIST'S NAME	BIRTHDATE	BIRTHPLACE	DEATHDATE	DEATHPLACE	AGE
White,[25] Elizabeth (P,Et)	Nov 22 1893	Sumter SC	Feb 6 1976	Sumter SC	82
*White, Henry Cooke (P)	Sep 15 1861	Hartford CT	Sep 28 1952	Waterford CT	91
*White, Minor (Ph)	Jul 9 1908	Minneapolis MN	Jun 24 1976	Boston MA	67
Whitlock, Mary Ursula (P)	Jan 6[26] 1860	Great Barrington[26] MA	Dec 7[27] 1944	Riverside[27] CA	84
*Whittemore, William John (P)	Mar 26[28] 1860	New York?[28] NY	Feb 7 1955	East Hampton NY	94
*Wiggins, Carleton (P)	Mar 4[29] 1848	Turner's[29] NY	Jun 11 1932	Old Lyme CT	84
*Wiggins, Guy C. (P)	Feb 23[30] 1883	Brooklyn[30] NY	Apr 25 1962	St. Augustine FL	78
Wiles, Irving Ramsey (P)	Apr 8[31] 1861	Utica[31] NY	Jul 29[32] 1948	Peconic[32] NY	87
*Willet, Anna Lee (P) (Mrs. William Willet)	Dec 15[33] 1866	Bristol[33] PA	Jan 18 1943	Atlanta GA	76
*Williams, Frerick Ballard (P)	Oct 21[34] 1871	Brooklyn[34] NY	Dec 11 1956	Glen Ridge NJ	85
Winegar,[35] Anna (P)	Aug 5 1867	Plainville MI	Oct 13 1941	Tucson AZ	74
*Winter, Charles A. (P,I)	Oct 26 1869	Cincinnati OH	Sep 23 1942	Gloucester MA	72
*Wolf, Henry (E)	Aug 3 1852	Eckwersheim Alsace	Mar 18 1916	New York NY	53
*Woolf, Samuel Johnson (P)	Feb 12 1880	New York NY	Dec 3 1948	New York NY	68
Wores,[36] Theodore (P,I)	Aug 1[37] 1858	San Francisco CA	Sep 11 1939	San Francisco CA	81
*Wyant, Alexander Helwig (P)	Jan 11[38] 1836	Evans Creek[38] OH	Nov 29 1892	New York NY	56

ARTIST'S NAME	BIRTHDATE	BIRTHPLACE	DEATHDATE	DEATHPLACE	AGE
*Wyant, Arabella Locke (P) (Mrs. Alexander H.)	Sep 12[39] 1841	Manchester[39] England	Oct 26 1919	Milan[40] NY	78

-Y-

Yates, Cullen (P)	Jan 24[1] 1866	Bryan[1] OH	Jul 1[2] 1945	East Stroudsberg[2] PA	79
*Young, Arthur ("Art") Henry (C)	Jan 14[3] 1866	Near Orangeville IL	Dec 29 1943	New York NY	77

-Z-

Ziegler,[1] Eustace Paul (P)	July 24 1881	Detroit MI	Jan 27 1969	Seattle WA	87
*Zorach, Marguerite (P)	Sep 25 1887	Santa Rosa CA	Jun 27 1968	Brooklyn NY	80

35

1. (1), II, 11.

2. (1), IV, 579.

3. (1); when his body was found on Nov. 7, it was estimated that he had been dead two days (NYT, Nov. 8, 1942, p. 50).

4. (1), II, 14.

5. (2), Milwaukee Psychiatric Hospital, Wauwatosa, Wis.; WWW gives birthdate as June 8, 1872 (II, 20).

6. (3), III, 27.

7. (2), Graceland Cemetery, Chicago, Ill.; her body was found on Dec. 26, 1929. She was the divorced wife of author Sherwood Anderson.

8. (2), PL, Jackson, Mich.; confirmed by CC.

9. (4), p. 10.

10. (2), F.

11. When Ashe is listed at all in the standard sources, his birthdate is always omitted; the correct year (no month or day listed) appears in Walt Reed, ed., The Illustrator in America 1900-1960's (New York: Reinhold Publishing Corp., 1966), p. 44.

12. (2), CC; Reed says 1941 (p. 44). Ob, Charleston (S.C.) News and Courier, May 22, 1942, p. 10.

13. Current Biography (1948), p. 29.

-B-

1. (4), p. 14.

2. (11), I, 351; ob. Dec. 25, 1911, p. 7.

3. (1), II, 34.

4. (4), p. 16.

5. (1), II, 35.

6. (2), F; an ob (containing no date of birth and the incorrect date of death) appeared in the Evanston (Ill.) <u>Review</u>, Jan. 2, 1946; a more exact ob appeared in the Roswell (N.M.) <u>Daily Record</u>, Dec. 16, 1963, p. 2.

7. (5), D.

8. (7), XVIII (1921), 345.

9. (4), p.22.

10. (4), p. 440.

11. (3), III, 59.

12. (1), II, 44.

13. (2), F.

14. (4), p. 23.

15. (8); year of birth confirmed by age listed in <u>NYT</u> ob; <u>Hav</u> incorrectly gives 1863 as year of birth (I, 103).

16. (5), D.

17. (1), II, 45.

18. (1), II, 46; <u>NYT</u> gives age as 82.

19. (1), II, 50.

20. (7), XVIII (1921), 351.

21. (2), TC; <u>Vol</u> incorrectly gives 1876 as year of birth (I, 188); <u>WA</u> gives age as 65 (II, 590).

22. (2), F.

23. (9), V, 20.

24. (4), p. 30.

25. (11), I, 680.

26. Ob, Washington (D.C.) _Post_, Dec. 20, 1970, p. B12.

27. (10), D.

28. (1), II, 580.

29. Percival Serle, _Dictionary of Australian Biography_ (Sydney: Angus & Robertson, 1949), I, 276. Serle, however, does not cite the month and day of Blashki's birth. Known in Australia as Miles Evergood, Blashki was the father of the American painter, Philip Evergood. Ob, Melbourne _Sun_, Jan. 4, 1939.

30. (2), F.

31. (1), II, 61.

32. (11), I, 712.

33. (8), XXXIII, 412.

34. _Smith_ incorrectly states that Bogert died in 1923 (p. 12); see Introduction, p. 7.

35. (7), XVIII (1921), 356.

36. (4), p. 33.

37. (2), Idaho State HS; see Introduction, pp. 8-9.

38. (1), I, 492.

39. (3), II, 71.

40. (2), F; incomplete obs, _Art Students League News_, IX (Feb. 1956) and the _New Mexican_, Sept. 20, 1956, p. 11B.

41. (1), II, 66.

42. (7), XIV (1917), 320.

43. (7), XVIII (1921), 361.

44. (5), D.

45. (2), F.

46. (2), F.

47. (1), II, 75.

48. Meryle Secret, _Between Me and Life: a Biography of Romaine Brooks_ (N.Y.: Doubleday, 1974), pp. 8, 17.

49. (4), p. 448.

50. (1), II, 79.

51. (1), II, 80; ob, Greenwich _Time_, Nov. 4, 1947.

52. (2), F.

53. (2). See Introduction, p. 4, and Kenneth H. Cook, South Boston (Va.) _News & Record_, Oct. 3, 1974, p. 1D. Birthdate confirmed by (2), F. The birthplace appears as "Long Island, Campbell County, Virginia" in Cook's article, but he informed me that the correct place is the one listed here.

54. Barbara Rose says Paris (_American Art Since 1900: A Critical History_ [N.Y.: Frederick A. Praeger, 1967], p. 95).

55. (2), F.

56. (4), pp. 51, 449.

57. (1), I, 494; _NYT_ gives age as 76.

58. (4), p. 52.

59. (1), II, 887.

60. (2), F.

-C-

1. (2), F.

2. (2), F; an incomplete entry is found in _Who Was Who_ (English), 1961-70, p. 178.

3. (2), CC.

4. (5), D.

5. (7), XVIII (1921), 374.

6. (2), F; NYT ob incorrectly gives birthdate as May 4, 1875.

7. Frederick A. Sweet, Miss Mary Cassatt: Impressionist From Pennsylvania
 (Norman, Okla.: Oklahoma University Press, 1966), pp. 7, 208. The year
 1845 is often cited as the birthdate, as in NYT ob and in Hav (1, 240);
 Bén is correct (I, 361).

8. (3), I, 204.

9. (2), F; the birthdate and birthplace are listed in WA, I-IV.

10. (1), II, 100.

11. Vertical file, NYPL.

12. (2), Fr; an ob appeared in the Daily Oklahoman, July 20, 1962.

13. (7), XVIII (1921), 377.

14. (4), p. 60.

15. Mimeographed vita prepared by family, vertical file, Pasadena (Calif.) PL;
 an incomplete listing--not updated to include his death--is found in Flg,
 p. 60.

16. (2), F.

17. (4), p. 451.

18. (1), II, 104.

19. (1), I, 86.

20. (1), II, 106.

21. (9), V, 380.

22. (3), II, 115.

23. (2), Salmagundi Club; NYT and Mal (p. 79) say NYC.

24. (1), II, 109.

25. Ob, <u>The South Reporter</u> (Holly Springs, Miss.), March 7, 1957.

26. (2), Marshall County HS, Holly Springs, Miss.; see Introduction, pp. 5-6.

27. (2), Amherst College.

28. (10), D.

29. (7), XVIII (1921), 383.

30. (9), V, 389.

31. (7), XVIII (1921), 383.

32. (7), Ibid., p. 384.

33. (5), D.

34. (4), p. 73.

35. (2), HS, Santa Barbara, Calif.

36. <u>DAB</u>, IV, 447.

37. (7), XVIII (1921), 389.

38. (2), F. <u>Current Biography</u> (1940) says only 1902 (p. 202). None of the sources that give 1904 cites the month and day. <u>Saturday Review of Literature</u> says Nov. 22, 1905 (XXX [Jan. 18, 1947], 8). See Introduction, p. iv.

39. Confirmed in Mexico City <u>Excelsior</u>, Feb. 6, 1957, Sect. B, p. 1, where, however, the exact birthdate does not appear. <u>NYT</u> says 53.

40. (1), II, 123.

41. Ob, Washington <u>Post</u>, March 9, 1967.

42. (1), II, 123-24.

43. (1), II, 125.

44. See Introduction, p. 4. Ellery Bicknell Crane's <u>Genealogy of the Crane Family</u> (Worcester, Mass.: Press of Charles Hamilton, 1900) confirms the April 2nd birthdate on the death record.

45. (5), B.

46. Ob, New London _Day_, March 26, 1974, p. 21.

47. (1), 1970, 86.

48. (1), II, 131.

-D-

1. (1), II, 133.

2. (1), II, 135.

3. (2),F; _Flg_ lists only the year of birth and gives Kansas City, Mo., as the birthplace (p. 88).

4. (4), p. 456.

5. (2), CC.

6. Ob, _NYT_, July 8, 1923, VI, 5.

7. _Flg_ agrees (p. 89); _Smith_ says 1865 (p. 27).

8. Brief death notice appeared in _NYT_, June 17, 1923, p. 7.

9. (9), V, 418; _Hav_ says 1863 (I, 339).

10. (7), XVIII (1921), 399.

11. Not to be confused with her mother, Mathilde J. De Cordoba, also a painter, who died on April 28, 1912 (Ob, _NYT_, April 30, 1912, p. 11).

12. (2), H; see Introduction, pp. 4-5. Ob, _NYT_, July 6, 1942, gives age as 71.

13. (2), F; Ob in _WA_ (1970), p. 539.

14. Emily Farnham, _Charles Demuth: Behind a Laughing Mask_ (Norman, Okla.: University of Oklahoma Press, 1971), p. 31.

15. (7) XVIII (1921), 401.

16. (1), II, 146.

17. (2), F; according to the family, no ob was published anywhere.

18. (2), F.

19. (5), D.

20. (2). Undated clipping labeled "New York *Times*," sent to me by the mortuary; the <u>NYT</u> ob I found does not mention the city of birth.

21. (2), TC; <u>AAA</u> says Feb. 14, 1868 (XVI [1919], 356).

22. <u>Bén</u> says "Morristown" [sic], no state (III, 285).

23. (7), XVIII (1921), 404.

24. Ob, Philadelphia <u>Public Ledger</u>, April 23, 1926, p. 24.

25. (1), II, 153.

26. (2), F.

27. "Winnishow" in Bén (III, 3247).

28. Morristown (N.J.) <u>Daily Record</u>, Aug. 31, 1948.

29. (1), II, 154.

30. (2), PL, Ipswich, Mass.

31. (4), pp. 101, 460.

32. (3), III, 240.

33. Ob, Millburne & Short Hills (N.J.) <u>Item</u>, Oct 3, 1957, which gives age as 86.

34. (2), F; <u>NYT</u> incorrectly lists age at death as 86.

35. (1), II, 597.

36. (9), V, 444.

37. (1), II, 159.

38. Ibid.

-E-

1. (3), I, 353.

2. (4), pp. 105, 462.

3. (4), pp. 107, 462.

4. (1), II, 161.

5. (1), II, 162.

6. (1), II, 597.

7. (1), II, 164.

8. (1), II, 166.

9. (7), XVIII (1921), 413.

-F-

1. (1), II, 175.

2. (2), F, and Current Biography (1955), p. 197.

3. (10), D.

4. (1), II, 176.

5. (11), III, 711.

6. (7), XVIII (1921), 417.

7. (2), Pratt Institute.

8. Smith says Cold Brook, N.Y. (p. 35).

9. (7), XIV (1917), 322.

10. (11), III, 774.

11. (3), III, 287.

12. (7), XXVIII (1931), 409.

13. (2), F; confirmed by WA. II, 183.

14. Ob, Ojai (Calif.) Valley News, Nov. 4, 1949, and Times (London), Nov. 23, 1949; the Times and Vol (V, 484) both give place of death as Ojai, Calif.

15. (3), IV, 321.

16. (1), I, 150.

17. (7), XVIII (1921), 421.

18. (3), I, 419.

19. (4), p. 127.

20. (1), II, 188.

21. (4), p. 128.

22. (5), D; listed as 1879 in WA, I-V.

23. 74 in NYT.

24. (5), B.

25. (7), XXVIII (1931), 410.

26. (1), II, 599.

27. (7), XVIII (1921), 424.
28. Ibid.

29. (3), IV, 336.

30. (9), V, 500.

31. Ob, Westporter Herald, Dec. 15, 1933.

32. (3), I, 431.

33. WWW says May 20 (I, 431).

34. (7), VIII (1910-11), 311.

35. (8), XII, 456.

36. (2), CC.

-G-

1. (8), XLII, 230.

2. Southwestern Art, II (March 1968, 42, 45.

3. (2), F; see Introduction, p. 3a; NYT ob and Current Biography (1966), p. 120, say Sept. 10.

4. (3), III, 315.

5. (4), p. 134.

6. (1), IV, 589.

7. (1), I, 163.

8. (2), CC.

9. (7), XVIII (1921), 430.

10. (1), II, 208.

11. (4), p. 470.

12. (7), XVIII (1921), 434.

13. (7), V, 362.

14. NYT says 72.

15. (2), CC.

16. NYT says 82.

17. (1), II, 221.

18. (1), II, 222.

19. (2), F.

-H-

1. (2), F.

2. (2), Whitney Museum of American Art, whose source was an exhibition catalogue, Samuel Halpert 1884-1930: A Pioneer of Modern Art in America (N.Y.: Bernard Black Gallery, 1969).

3. (7), XVIII (1921), 443.

4. Ibid.

5. AAA (XXVI [1929], 389) and NC (XXVI, 163) both say May 12.

6. (1), II, 233.

7. Ob, Poughkeepsie (N.Y.) Courier, July 22, 1946.

8. (7), XIV (1917), 506.

46

9. (3), I, 532-33.

10. (8), XXII, 452; <u>NYT</u> ob gives birthdate as Jan. 8, 1872, and birthplace as "Maine"; see Introduction, p. 7.

11. (7), XVIII (1921), 447.

12. Ibid., p. 448; confirmed by death record.

13. (1), II, 239.

14. (2), CC; <u>WWW</u> gives date of death as April 28, 1950 (III, 387).

15. (1), I, 195.

16. William Innes Homer, <u>Robert Henri and his Circle</u> (Ithaca, N.Y.: Cornell University Press, 1969), p. 10; <u>NYT</u> gives birthday as June 25.

17. (4), pp. 166, 476.

18. (1), II, 244.

19. (1), IV, 221.

20. (2), F.

21. <u>NYT</u> says Massachusetts.

22. (9), II, 442; <u>WA</u> says "Feb. 1874" (II, 246).

23. (1), II, 246.

24. (5) D.

25. (5), D. Ob, Los Angeles <u>Times</u>, June 14, 1930, p. 2.

26. (2), F.

27. (1), I, 202.

28. (2), Art Institute, Chicago.

29. (11), IV, 718.

30. (1), II, 251.

31. Malvina Hoffman, <u>Yesterday is Tomorrow</u> (N.Y.: Crown Publishers, 1965), p. 29.

32. (9), II, 468.

33. (4), p. 478.

34. (1), II, 257.

35. Ob, Middletown (N.Y.) <u>Daily Record</u>, June 23, 1960, p. 5A.

36. (2), F.

37. (2), Highland County, HS, Hillsboro, Ohio.

38. The death certificate gives the day of birth as Aug. 23, but it appears as Aug. 28 in both <u>WA</u> (III, 318) and Violet Morgan <u>Folklore of Highland County</u> (Greenfield, Ohio: Greenfield Pub. Co., 1946), pp. 224-25.

39. (11), IV, 44; <u>Bén</u> gives middle initial as "N," <u>NYT</u> as "L."

40. <u>NYT</u> says 59.

-I-

1. (5), D.

2. <u>Flg</u> (p. 184) and <u>Mal</u> (p. 210) say Milan, Italy.

3. (2), F.

4. <u>NYT</u> says 68.

-J-

1. (1), II, 276.

2. (10), D.

3. Death record states only "October 19" (no year).

4. Death record lists age as "about 82," but cemetery reports birth on gravestone is recorded as 1871.

5. (11), V, 159; the town appears incorrectly as "Lowell" in <u>Flg</u>, who gives birthdate as "Aug. 1824" (p. 483).

48

6. (7), XVIII (1921), 465.

7. (5), D.

-K-

1. NYT says 74.

2. (2), F; Flg gives birthplace as Brooklyn, N.Y. (p. 194).

3. (8), XLV, 334.

4. NYT says 82.

5. (4), p. 484.

6. (1), II, 289.

7. (2), attorney for the estate. This is the legal date, but, according to a
 member of the family, no one really knows exactly when she died; she had been
 dead about a week when her body was found. The ob appeared on Oct. 11th.

8. (1), II, 294.

9. NYT says 80.

10. (2), F.

11. AAA, XXX (1930), 590, and Mal (p. 234) both say 1870.

12. (5), B and D; see Introduction, p. 6.

13. Death record says 38.

14. (2), TC; WA says June 5, 1881 (II, 302).

15. NYT, Sept. 20, 1949, says 71 (p. 29); WA (1953) says 68 (p. 548).

16. (10), D.

17. The exact birthdate is not recorded on the death certificate; no birth
 certificate could be found in 1875-76.

18. (1), II, 304.

19. (2), PL, Boston, Mass.

20. Flg says 1880 (p. 486).

-L-

1. (4), p. 486.

2. (4), pp. 207, 487.

3. Ibid.

4. Ob, American Art News, Jan. 4, 1908, p. 6.

5. (3), I, 707.

6. (9), III, 182.

7. (1), II, 315.

8. His death is discussed in news article, NYT, Dec. 19, 1939, p. 48 (not indexed in NYT Obituaries Index 1858-1968).

9. (1), II, 316.

10. (1), II, 320.

11. Beth Stokes, A.F. Levinson, Artist (New York: New York University, 1964), p. 1.

12. (3), I, 320.

13. (9), III, 221.

14. (2), F.

15. Ob, Art Digest, XIV (Jan. 15, 1940), 27.

16. (10), D; Flg spells name "Lindin" (p. 217).

17. Vol says July 15, 1869 (III, 237); the date appears as June 15, 1869, in the files of the Woodstock (N.Y.) Art Association.

18. Ob, Winter Park (Fla.) Sun-Herald, Nov. 27, 1963.

19. (7), XXV (1928), 347.

20. Ibid., p. 398.

21. (7), XVIII (1921), 486.

22. (2), F; AAA says "near Syracuse."

23. (2), Providence Journal and Evening Bulletin.

24. NYT says 45.

25. (1), II, 332; Flg says 1866 (p. 220)

26. (4), p. 491.

27. (2), IV, 595.

28. (7), XVIII (1921), 487. ,

29. (1), I, 506.

-M-

1. (1), II, 337.

2. (7), XVIII (1921), 491.

3. (11), V, 157.

4. (7), XVIII (1921), 493; Hav says 1866 (II, 780).

5. (1), II, 328; Smith says Boston (p. 61).

6. (2), Canadian Embassy, Rabat-Agdal, Morocco.

7. NYT says 62.

8. (1), II, 608.

9. (2), F.

10. Edward MacDowell Association, Bulletin #2 (1922).

11. (4), p. 493.

12. (3), III, 546.

13. (2), F; confirmed by AAA, XVIII (1921), 496.

14. (7), XVIII (1921), 496.

15. NYT says 36.

16. (4), pp. 227, 493.

17. (1), I, 278.

18. (5), D.

19. (2), F.

20. (4), pp. 230, 494; NYT gives birthdate as "1838."

21. Ob, Providence (R.I.) Journal, Dec. 25, 1941.

22. (2), TC; Providence Journal says May 2.

23. (7), XXIX (1932), 427; birth in NYC confirmed by Elizabeth McCausland,
 A. H. Maurer (N.Y.: A. A. Wyn, 1951), p. 25.

24. (7), XII (1914-15), 427.

25. (4), p. 491.

26. (1), II, 353.

27. Macmillan Dictionary of Canadian Biography, ed. W. Stewart Wallace, 3rd ed.
 (London: Macmillan, 1963), p. 468; Flg says only "Ontario, Canada" (p. 236).

28. (2), F; an ob appeared in The Newspaper of Shrewsbury, N.J., Jan. 20, 1972.

29. Susan Porter Green, Helen Farnsworth Mears (Oshkosh, Wis.: Paine Art Center
 and Arboretum, 1972), pp. 9, 113. NC says 1872 (XXV, 287).

30. NYT ob says 37.

31. (7), XVIII (1921), 503.

32. NYT says 68.

33. (3), I, 837; Hav says birth year was 1864 (II, 847).

34. (4), p. 497.

35. (1), II, 365.

36. (3), I, 844.

37. (8), XII, 354; Flg gives the year of birth as "1839 or 1840" (p. 497).

38. (7), XII, 432.

39. (2), F.

40. (10), D.

41. (2), Kirk and Nice, Undertakers, Philadelphia; the death record does not contain exact birthdate or birthplace.

42. (7), XXII (1925), 302.

43. NYT says Philadelphia; ob, Philadelphia Public Ledger, Jan. 7, 1925, confirms both birthplace and place of death.

44. (1), II, 371.

45. (4), p. 246.

46. (11), VI, 240.

47. (3), III, 623.

48. (5), D; see Introduction, pp. 8-10.

49. (1), II, 376.

50. (7), XVIII (1921), 511.

51. (1), II, 377.

52. (1), II, 378.

53. (4), p. 499.

-N-

1. (1), II, 380.

2. (7), XVIII (1921), 513.

3. (5), D.

4. 1900 Federal Census; no record of birth is on file in Washington, D.C.; death record contains no birthdate but gives age as 80, which, the informant wrote me, was an educated guess.

5. (2), CC; NYT says "Berrien County, Michigan."

6. NYT says 77.

7. (1), II, 384.

8. (4), pp. 258, 500.

9. (1), II, 385.

10. (5), D.

-0-

1. 2, CC; confirmed by Princeton University alumni records; NC says Oct. 31, 1878 (XXIX, 426).

2. (7), XVIII (1921), 519.

3. Ibid., p. 520.

4. (9), III, 514.

5. (2), F.

6. (1), 1962, p. 463.

7. Ob, San Rafael (Calif.) Independent Journal, Feb. 26, 1962.

-P-

1. NYT says 87.

2. (1), II, 400.

3. (2), F.

4. (4), p. 270.

5. (2), TC.

6. (1), II, 407.

7. (4), p. 504.

8. (2), F.

9. (3), I, 962.

10. (2), F.

11. (2), F.

12. (4), p. 505.

13. (2), F.

14. (2), White Plains Rural Cemetery, White Plains, N.Y.

15. <u>AAA</u> says White Plains, N.Y. (XXIX [1932], 429).

16. (1), II, 420.

17. (7), XIV (1917), 326.

18. (1), II, 421.

19. Hedley Powell Rhys, <u>Maurice Prendergast</u> (Cambridge, Mass.: Harvard University Press, 1960), p. 20; <u>AAA</u> says "October 1861" (XIV [1917], 536) and <u>Flg</u> says 1861 (p. 290).

20. <u>Flg</u> says Boston (p. 290).

21. (2), Fr.

22. (2), F.

23. (11), VII, 62.

-Q-

1. (1), 1962, p. 494.

2. (2), F.

-R-

1. (2). The Whitney Museum of American Art wrote me that the Chapellier Gallery was their source for the birthdate; <u>Flg</u> says 1847 (p. 293).

2. (4), p. 293.

3. Ob, Philadelphia <u>Inquirer</u>, March 17, 1915, p. 16; according to the newspaper, Ramsey was in his sixty-ninth year.

4. New Bedford (Mass.) <u>Standard Times</u>, June 29, 1947, <u>AAA</u> says "Jan. 1858" (XIV [1917], 326); death certificate gives no birthdate but cites age as "58 years 9 months."

5. (7), XIV (1917), 326; death certificate says only "U.S."

6. (2), F; WWW gives only 1869 (IV, 781); catalogue by Grand Central Art
 Galleries of NYC (1968) gives brief biographical sketch.

7. (3), IV, 781.

8. (11), VII, 156.

9. (4), pp. 299, 508.

10. (7), XVIII (1921), 543.

11. (1), II, 435.

12. (1), III, 724.

13. (6), p. 368.

14. The Official Encyclopedia of Bridge (N.Y.: Crown Publishers, 1971), p. 681.

15. (7), XVI (1919), 482.

16. (1), II, 440.

17. (1), I, 355.

18. (2), TC, who quoted excerpt from A. S. Rix, Rix Family of America, pp. 93-94;
 see Introduction, p. 4.

19. AAA says San Francisco (XXV [1928], 406).

20. (10), D; NYT ob says 62.

21. (7), XVIII (1921), 546.

22. (4), p. 304.

23. Ob, Miami Herald, Aug. 9, 1950.

24. (1), II, 442; see Introduction, pp. 7-8.

25. (5), D.

26. (4), p. 509.

27. (1), II, 443.

28. (3), I, 1044; <u>WA</u> says Boston, Mass. (II, 443); the TC, Taunton, could not find any birth record under name of Florence Vincent Robinson or Florence Vincent, nor could the Registrar of Boston.

29. <u>WWW</u> says March 30 (I, 1044).

30. (11), VII, 289.

31. (4), p. 306; Bén says Irasburg, but gives no state (VII, 289).

32. Bén says April 1 (VII, 289).

33. (7), XVIII (1921), 548.

34. (2), Lawrence and Memorial Hospital, New London, Conn.

35. (3), IV, 809.

36. Ob, Los Angeles <u>Times</u>, Nov. 18, 1925, II, pp. 1-2.

37. (7), XVIII (1921), 548.

38. (1), II, 448.

39. (1), II, 449.

40. Ibid.

41. (1), II, 451.

42. (1), I, 513.

43. (1), II, 452.

44. Ramon F. Adams and Homer E. Britzman, <u>Charles M. Russell, The Cowboy Artist: A Biography</u> (Pasadena, Calif.: Trail's End Publishing Co., 1948), p. 1; <u>NYT</u> ob says 1865.

45. <u>NYT</u> ob says 61.

46. (9), IV, 133.

47. (2), F; <u>NYT</u> says Philadelphia.

48. (1), II, 454.

1. Ob, Philadelphia Bulletin and Philadelphia Inquirer, both April 21, 1968.

2. (2), F.

3. (7), XVIII (1921), 554.

4. (11), VII, 532; confirmed by ob, American Art News, June 13, 1908, p. 4.

5. NYT says 65.

6. Ob, Columbus Dispatch, Nov. 7, 1955, p. 6B.

7. News article, NYT, Nov. 6, 1912, p. 24.

8. (2), F.

9. (7), XXV (1928), 407, confirmed by cemetery records, though the TC of
Monroe could not find the record there; NYT says Cleveland, Ohio.

10. (7), XVIII (1921), 557.

11. NYT ob says 75.

12. (7), XVIII (1921), 558.

13. (2), F.

14. (2), F.

15. Ob, Cincinnati Enquirer, Nov. 16, 1935, p. 1.

16. (1), II, 472.

17. (7), XVIII (1921), 561.

18. (3), I, 1106.

19. (2), F.

20. (7), XIV (1917), 327; NYT ob gives Lindley, Ohio, as birthplace, but Findlay
is confirmed in ob, American Art News, Jan. 13, 1917, p. 4.

21. NYT ob says 37.

22. (7), XVI (1919), 498.

23. (3), IV, 854.

24. (2), Edith DeShazo, in whose book, <u>Everett Shinn (1876-1953): A Figure in</u> <u>his Time</u> (M.Y.: Clarkson N. Potter, 1974), only the year of birth is given; but she informed me that she obtained the complete birthdate from the birth certificate. <u>AAA</u> says Nov. 6, 1873 (XIV [1917], 606); <u>WA</u> says Nov. 7, 1876 (IV, 423); and <u>Flg</u> says Nov. 6, 1878 (p. 515). <u>NYT</u> ob gives year of birth as 1873 and age at death as 79. See Introduction, p. iv.

25. (4), p. 515.

26. (7), XVIII (1921), 565.

27. (1), II, 495.

28. (2), Chester County HS, West Chester, Pa.; <u>NYT</u> ob and <u>NC</u> (X, 378) give birth year as 1858, but ob, West Chester (Pa.) <u>Local Daily News</u>, March 27, 1920, gives year as 1857, as does Gilbert Cope, <u>Genealogy of the Smedley</u> <u>Family</u> (Lancaster, Pa.: Wickersham Printing Co., 1901), p. 580; the genealogy gives the birthplace as West Bradford, Pa., whereas the <u>Local</u> <u>Daily News</u> ob says East Bradford, an adjacent town.

29. <u>NYT</u> says 62.

30. (7), XVIII (1921), 567.

31. (2), Cornell University; confirmed by Art Center, Maitland, Fla.

32. (2), F.

33. (4), p. 343.

34. News article, <u>NYT</u>, July 12, 1931, II, p. 1 (not indexed in <u>NYT Obituaries</u> <u>Index</u>).

35. (7), XII (1914-15), 477.

36. (2), Fr.

37. (3), III, 809.

38. (2), Fr, University of Miami (Fla.), which has major Spicer-Simson collection.

39. (1), II, 497.

40. (1), 1970, p. 408.

41. (3), V, 684.

42. (2), TC, Babylon, N.Y.

43. (2), F; Flg says Milwaukee, Wis. (p. 349).

44. Irma B. Jaffe, Joseph Stella (N.Y.: Praeger, 1970), p. 238; WA II, 501 and III, 616, say 1880.

45. NYT ob says 70.

46. Flg gives date as July 13, 1878 (p. 517).

47. (1), II, 502.

48. (2), Joseph Solomon, Trustee of Ettie Stettheimer's estate. See "Florine," The New Yorker, XXII (Oct. 5, 1946), 27. AAA says born in "New York" (XXVI [1929], 795).

49. Current Biography (1940), p. 674.

50. (5), D, which does not give the town in Michigan. It is belatedly identified, however, in a letter from Fresh Pond Crematory, Middle Village, NY.

51. (1), IV, 451; NYT ob says 51; WA says 52 (1953, p. 549).

52. (2), Diplomatic Branch, National Archives.

53. (4), p. 354.

54. (1), II, 647.

55. (10), D; see Introduction, p. 6.

-T-

1. (4), p. 359.

2. <u>Flg</u> says July 21 (p. 518).

3. <u>Flg</u> says NYC (p. 518).

4. (4), p. 359.

5. (4), p. 360.

6. <u>Flg</u> says May 25 (p. 519).

7. (7), XXII (1925), 695.

8. (2), Gibbes Art Gallery, Charleston, S.C.

9. (1), II, 516.

10. (11), VIII, 239.

11. (4), p. 363.

12. (7), XVIII (1921), 583.

13. (2), F.

14. (5), D.

15. (3), IV, 939.

16. (2), F.

17. (5), D.

18. Ob, Boston <u>Transcript</u>, Aug. 31, 1935, p. 14.

19. (8), XIII, 398.

20. (7), XIII (1916), 319.

21. (3), I, 1239.

22. (2), Smith College.

23. (1), II, 530.

24. (1), II, 531.

25. (3), I, 1259; confirmed by ob, <u>American Art News</u>, Feb. 10, 1915, p. 7.

26. (1), II, 532.

-U-

1. (1), II, 533.

-V-

1. (7), XXIX (1932), 432.

2. (5), D.

3. Smith, p. 94.

4. Ob, Amsterdam (N.Y.) Evening Recorder, May 12, 1945, p. 3.

5. (2), F.

6. Ob, NYT, March 24, 1920, p. 9.

7. (7), XIV (1917), 630.

8. (2), Librarian, Faculty of Philosophy, Charles University, Prague, Czechoslovakia.

9. The National Gallery of Prague informed me that the deathdate was June 26th, but the 28th is confirmed in ob, Prague Lidova Demokracie, July 2, 1970.

-W-

1. Emily Herbert, Encyclopedia Canadiana (Toronto: Grolier Society of Canada, 1970), X, 253.

2. (1), II, 545.

3. Ob, Philadelphia Inquirer, Jan. 20, 1976.

4. Catalogue, Hammer Galleries, exhibition of Dec. 9, 1975-Jan. 3, 1976.

5. (1), II, 546.

6. (1), II, 548.

7. (1), II, 549.

8. (5), D.

9. (4), p. 393; "Unknown" on death record. See Introduction, p. 3.

10. Ob, Norfolk (Va.) Ledger-Dispatch, June 19, 1913, p. 1; Flg lists no city (p. 393).

11. WWW says "June 1912" (I, 1104).

12. NYT says 83.

13. Confirmed by Alfred Werner, Max Weber (N.Y.: Harry N. Abrams, 1975), p. 26; AAA says 1880 (XVIII [1921], 613).

14. (9), V, 90; confirmed by Werner.

15. (1), II, 554.

16. Dorothy Weir Young, The Life & Letters of J. Alden Weir (New Haven, Conn.: Yale University Press, 1960), p. 1.

17. (2), TC.

18. NYT says Wilbraham, Mass.

19. (1), II, 559.

20. (7), XII, 502.

21. Stanley Weintraub, Whistler: A Biography (N.Y.: Weybright and Talley, 1974), p. 4; Flg agrees, but Pennell and Bén both say July 10.

22. (5), D.

23. (7), XII (1914-15), 502; birthdate is not on death record.

24. See Introduction, p. 6.

25. Ob, Columbia (S.C.) State, Feb. 5, 1976.

26. (7), XVIII (1921), 607.

27. Ob, Riverside (Calif.) Daily Press, Dec. 8, 1944, p. 14. See Washington Star, Jun 17, 1945.

28. (7), XVIII (1921), 608.

29. Ibid., p. 609; Flg spells the birthplace "Turners" (without the apostrophe), p. 408.

30. (7), XVIII (1921), 609.

31. (1), II, 566.

32. (9), V, 135.

33. (7), XVIII (1921), 610.

34. (1), II, 569.

35. Ob, (Tucson) Arizona Daily Star, Oct. 15, 1941.

36. Lewis Ferbraché, Theodore Wores: Artist in Search of the Picturesque
 (San Francisco, Calif., 1968), pp. 2, 60.

37. Flg says 1860 (p. 417).

38. DAB, XX, 572; NYT ob gives birthplace as Fort Washington, Ohio.

39. (5), B; see Introduction, p. 6; death certificate gives birthplace as
 "England."

40. NYT ob says Red Hook, N.Y.; AAA says Arkville, N.Y. (XVI [1919], 225).

-Y-

1. (3), II, 597.

2. Ob, Stroudsburg (Pa.) Daily Record, July 2, 1945, p. 1

3. (3), II, 597.

-Z-

1. (2), F. An ob, which does not cite place of death, appeared in the Seattle
 Post-Intelligencer, Jan. 28, 1969, p. 33.